JAMIE WYETH

JAMIE WYETH

HOUGHTON MIFFLIN COMPANY

Boston 1980

The painting *Bronze Age* is copyright © 1969,
William A. Farnsworth Library and Art Museum,
Rockland, Maine, and is reproduced with permission.

Library of Congress Cataloging in Publication Data
Wyeth, Jamie, date
 Jamie Wyeth.
 1. Wyeth, Jamie, 1946-
ND237.W935A4 1980 759.12 80-15329
ISBN 0-395-29167-4

Printed in the United States of America

H 10 9 8 7 6 5 4 3 2 1

FIRST PRINTING

JAMIE WYETH has said that he thinks art books should concentrate on the artist's work, including, perhaps, a small amount of biographical detail but avoiding the traditional scrim of interpretation that comes between artist and audience. Art books, in short, should be seen rather than read. Here, therefore, is a brief sketch of the artist's life, without the usual critical gloss.

James Browning Wyeth was born on July 6, 1946, the youngest child of Andrew Wyeth and the grandson of the famed illustrator N. C. Wyeth. Like his father before him, Jamie displayed early artistic promise and an independent streak wider than the Brandywine River on whose shores he grew up. After finishing the sixth grade, he implored his parents to take him out of school so that he could study at home with a tutor. His mother was worried, the local school board was dismayed, but his father sympathized completely. Andrew Wyeth had himself been taught by a tutor because of a childhood illness and, to this day, credits that fact with the unfettered development of his imagination. Thus, from an early age, Jamie lived freely in the world of *Robin Hood* and *Treasure Island* and other Anglo-Saxon fantasies that his grandfather had so graphically brought to life. And, when the spirit moved him, he transposed his fantasy world onto paper, creating his own characters and dramas in pen and ink.

In 1958 his freedom came to an end. Jamie "went into studio" with his aunt Carolyn Wyeth, a noted painter in her own right, who had volunteered to begin Jamie's formal art training. Now the schedule became considerably more rigorous: three hours in the morning with the tutor, and four in

the afternoon with Carolyn, working in charcoal, doing still lifes in NC's old studio. Two years later, Andrew took over Jamie's education, just as Andrew's father had taught him. This was not the usual art school relationship between teacher and student, but a true apprenticeship, in which the novice learns his craft while observing and working with the mature craftsman.

Finally, after three years working alongside his father, Jamie struck out on his own. Convinced that he needed a better understanding of anatomy, he moved to New York City and set up an informal studio of his own in the most unlikely place – the morgue of one of the major metropolitan hospitals.

Jamie's first oil paintings began to appear soon thereafter, in 1963. By 1967 he had painted *Draft Age* and a posthumous portrait of John F. Kennedy, both of which brought him public recognition and critical acclaim. Before he had turned twenty, he had held his first major show at the Knoedler Gallery in New York. It was now clear that the third generation of America's first family of painting had been established.

CONTENTS

JAMIE WYETH

SITTERS

OF THE VARIOUS ART FORMS that Jamie Wyeth has mastered, portraiture stands out as the first among equals. Jamie does not paint a portrait as much as he lives it. He spends so much time studying his subjects that he begins to take on their mannerisms, interests, and even their speech patterns. The portrait of Lincoln Kirstein—one of Jamie's first—took some three hundred hours of posing, not to mention frequent trips to the ballet so that the artist could observe Kirstein in his own element.

The challenge to paint a posthumous portrait of John F. Kennedy led to months of research into every facet of the late president's life. Jamie spent literally hundreds of hours watching films of JFK so that he could establish a "living memory" of a man he had never met. Before he painted the finished portrait, he was able to sketch JFK from any angle, with barely any reference to photographs.

The ballet beckoned again when Jamie undertook a portrait of Rudolf Nureyev. One night, in order to better appreciate the dancer's tension before a performance, Jamie hid onstage and was engulfed in the surge of applause when the curtain rose.

The milieu of Andy Warhol was at once more and less familiar. As an artist, Jamie understood and admired Warhol, but it was as a creature of New York's cosmopolitan epicenter that he had to get to know him. Jamie and Andy would frequently descend into the bowels of the city for their evening walks along the subway platforms. Warhol, in turn, was uncomfortable in the country. When he visited the Wyeths on their farm in Chadds Ford, he would always joke that he came only because the television reception was better.

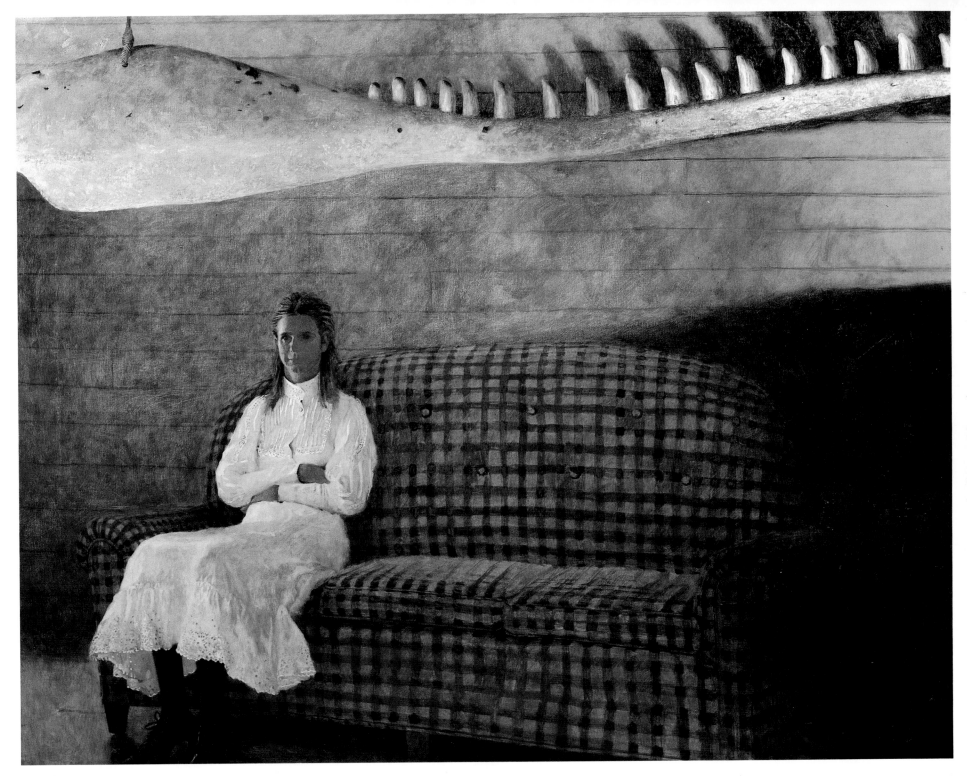

WHALE

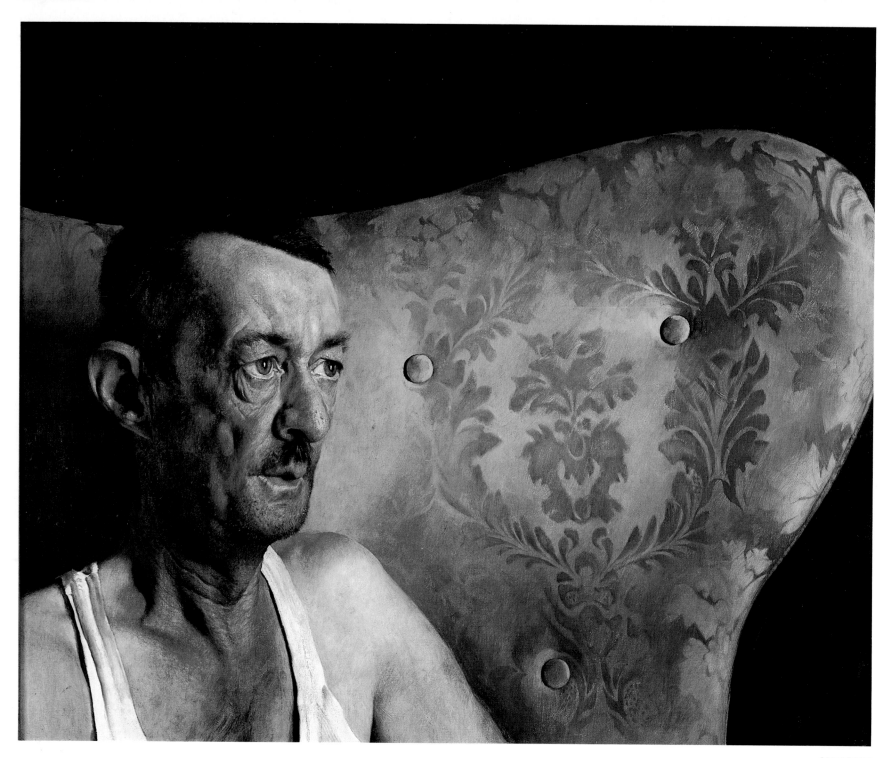

SHORTY

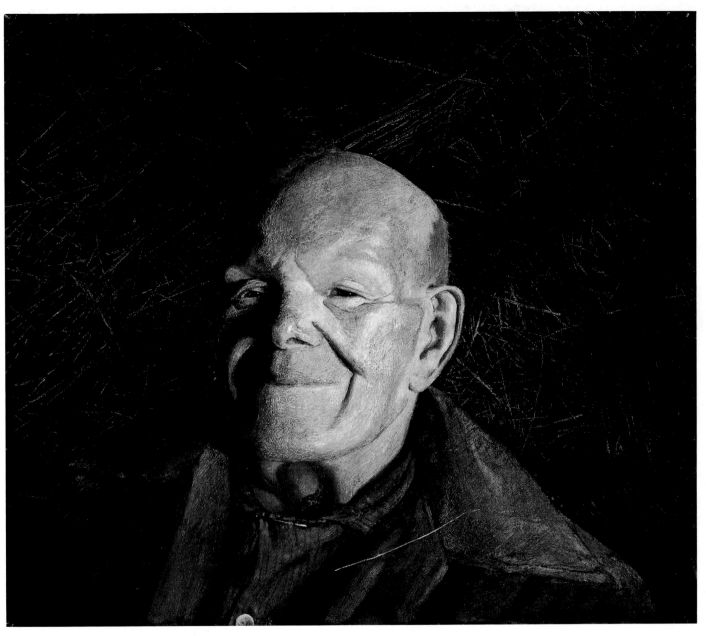

HALLOWEEN

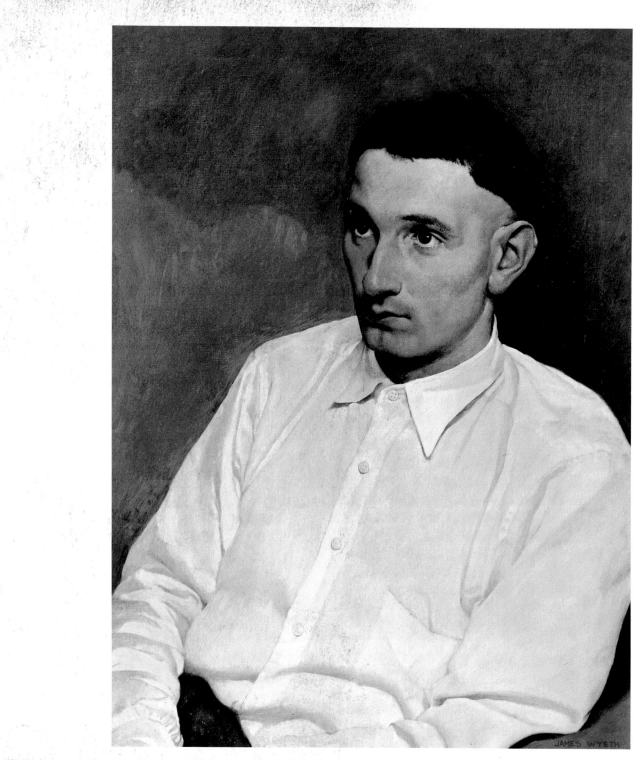

LESTER

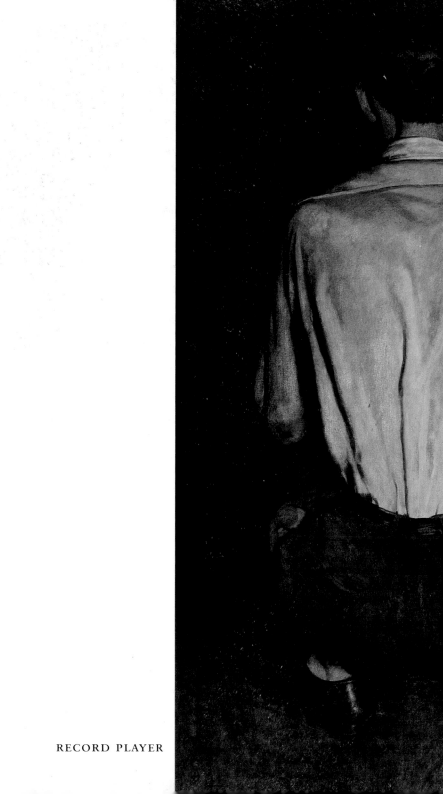

RECORD PLAYER

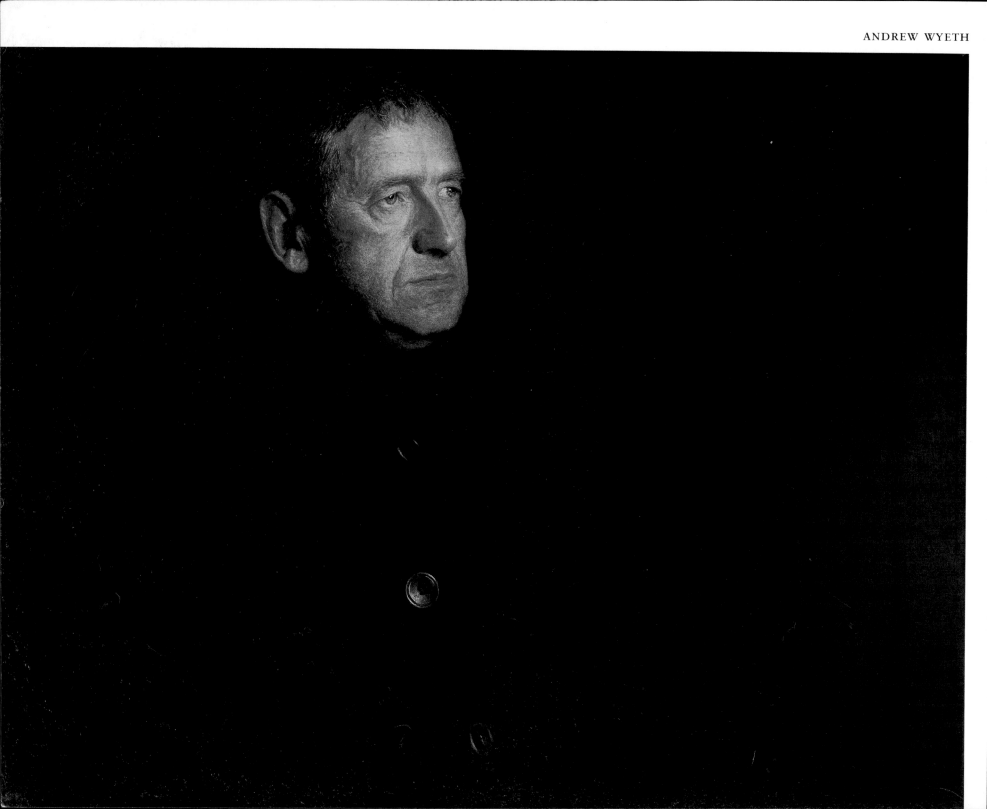

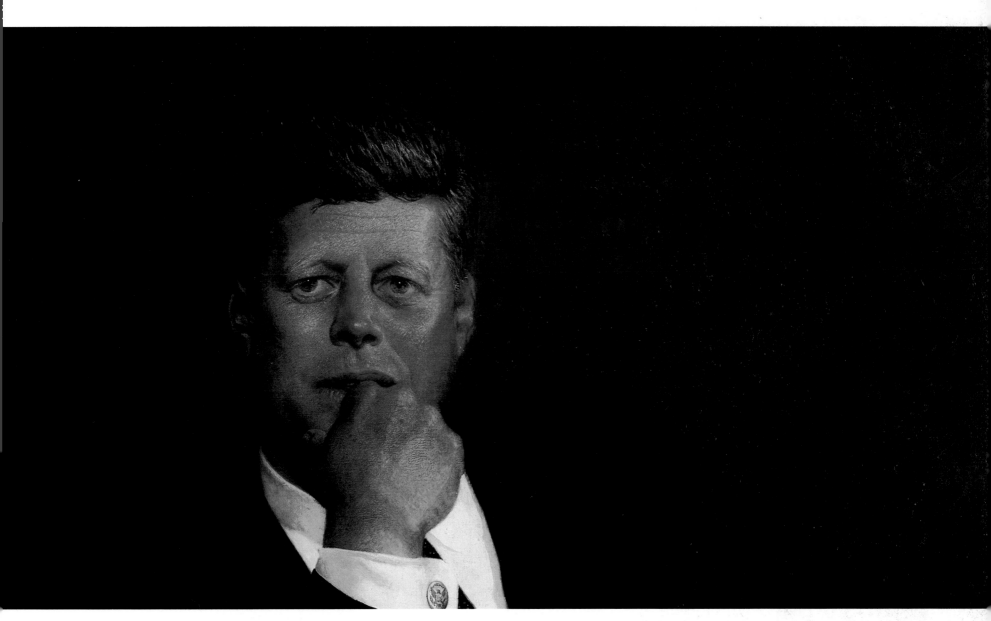

PORTRAIT OF JOHN F. KENNEDY

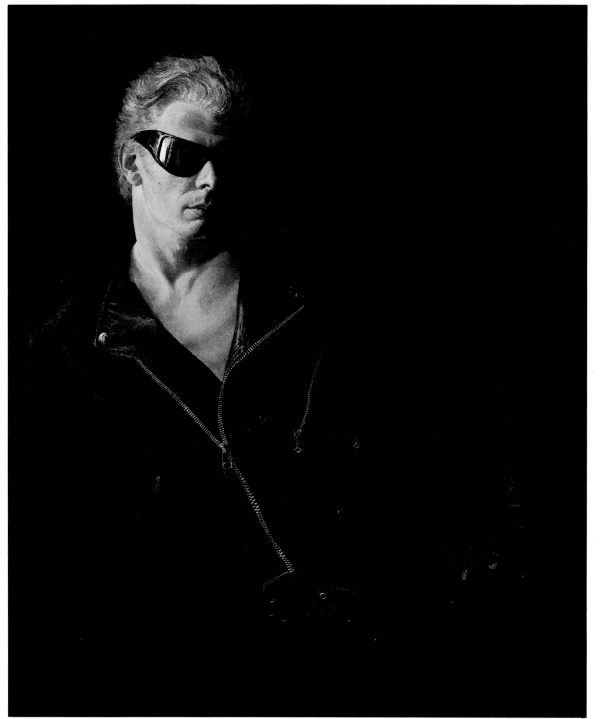

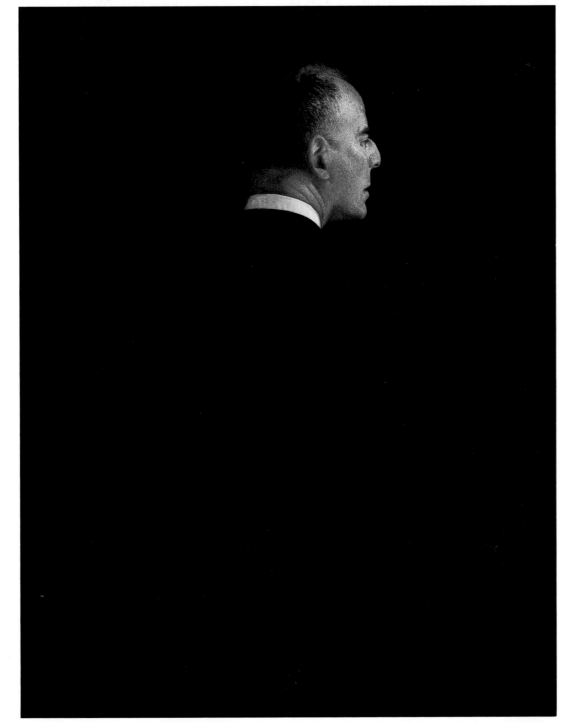

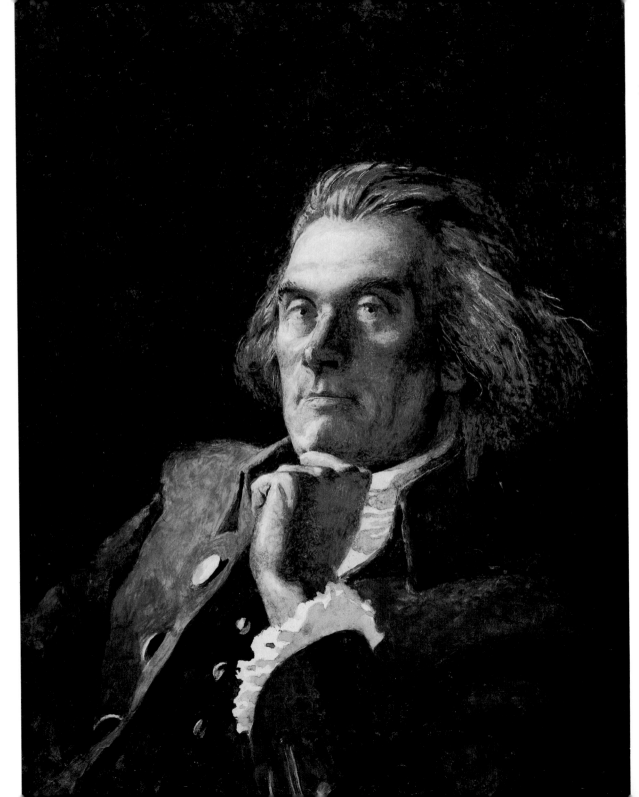

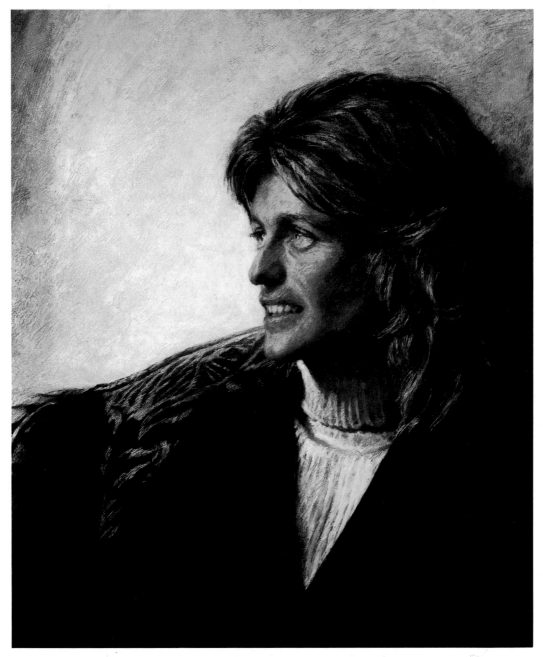

PORTRAIT OF JEAN KENNEDY SMITH

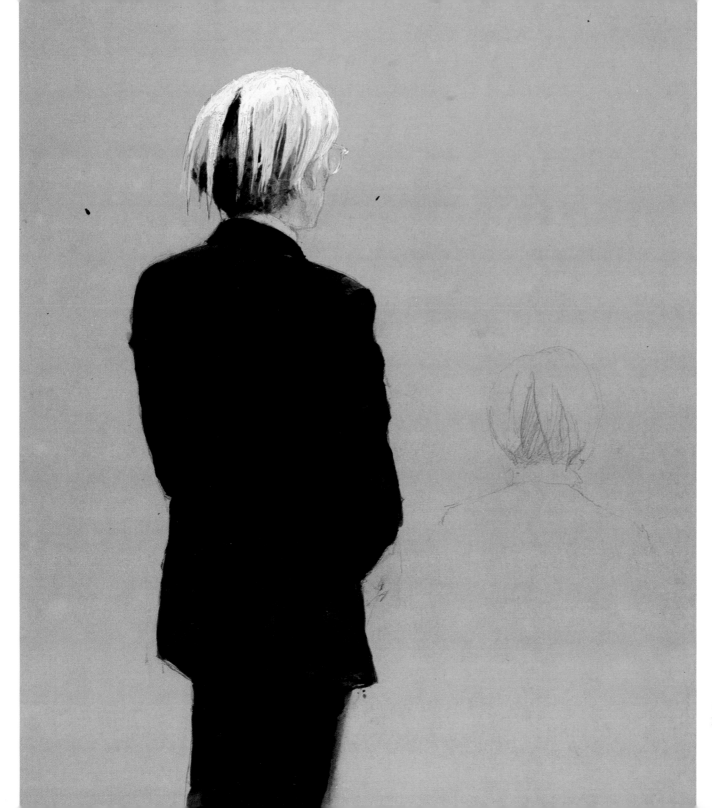

ANDY WARHOL—
BACK VIEW, STANDING

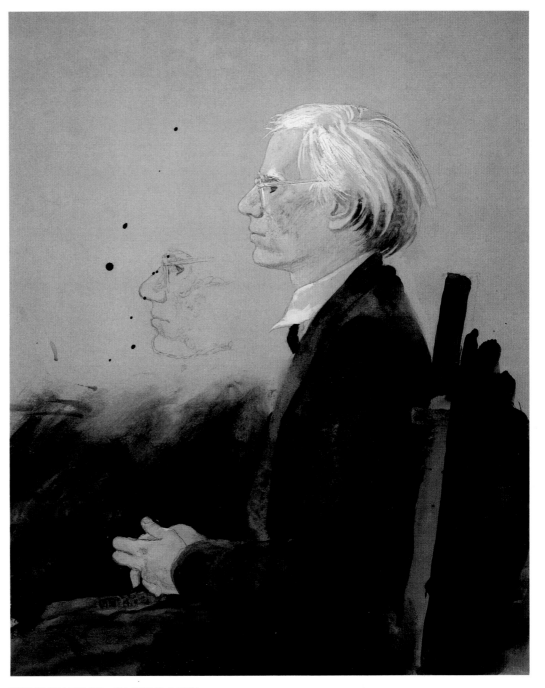

ANDY WARHOL—FACING LEFT

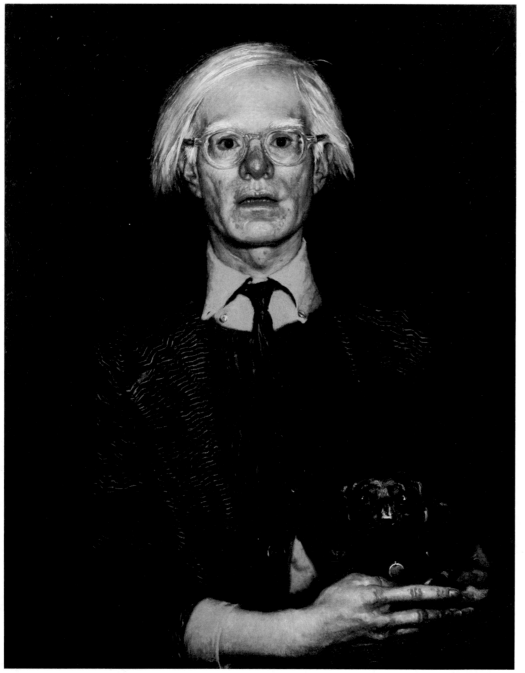

PORTRAIT OF ANDY WARHOL

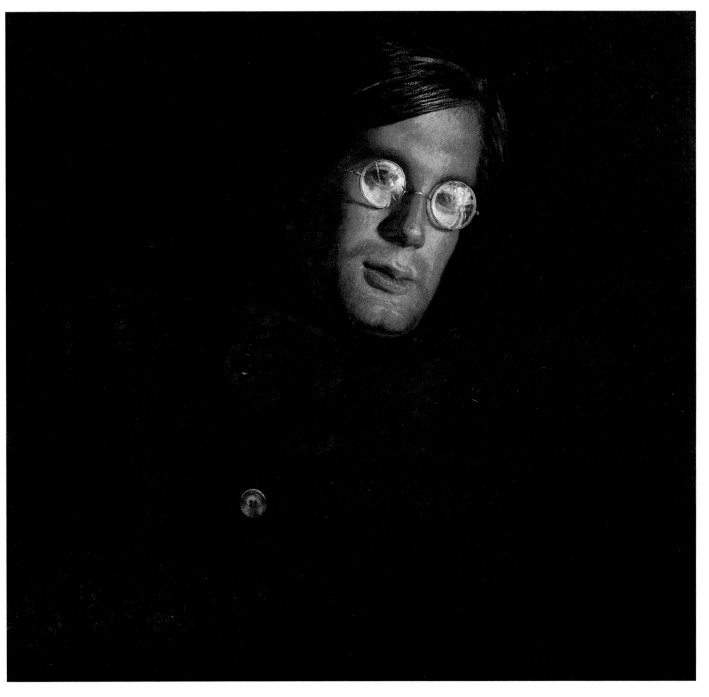

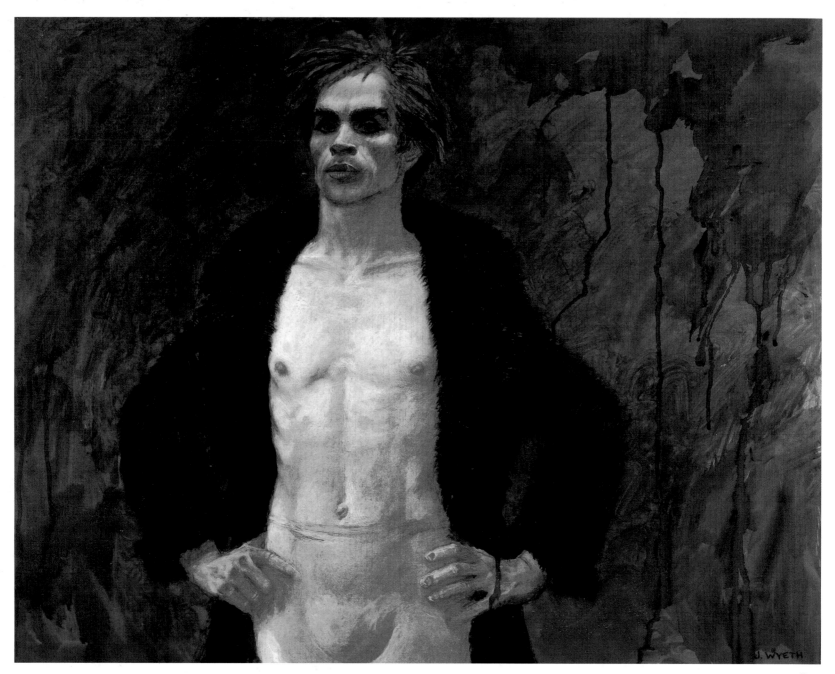

RUDOLF NUREYEV—STUDY #25

RUDOLF NUREYEV

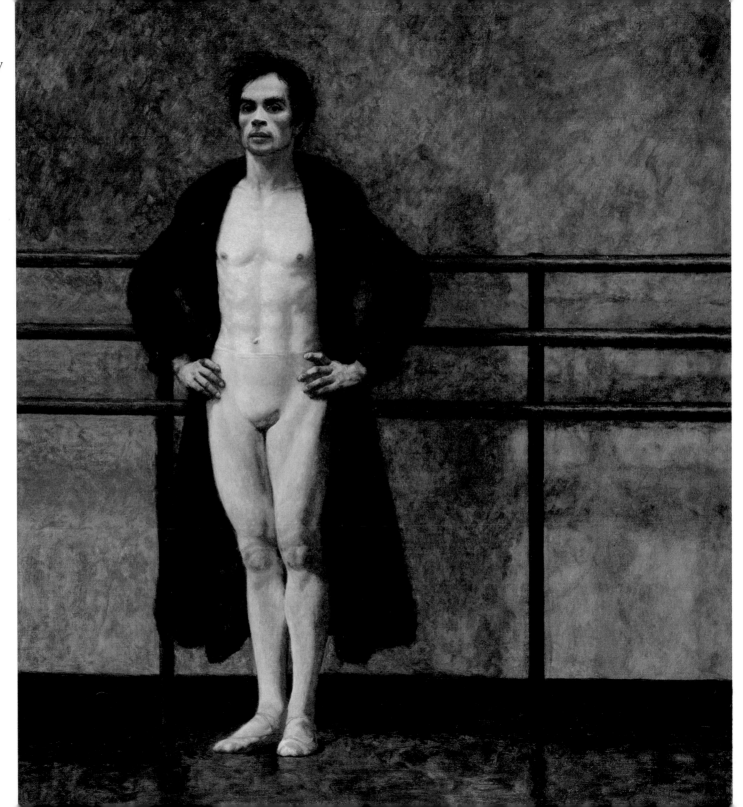

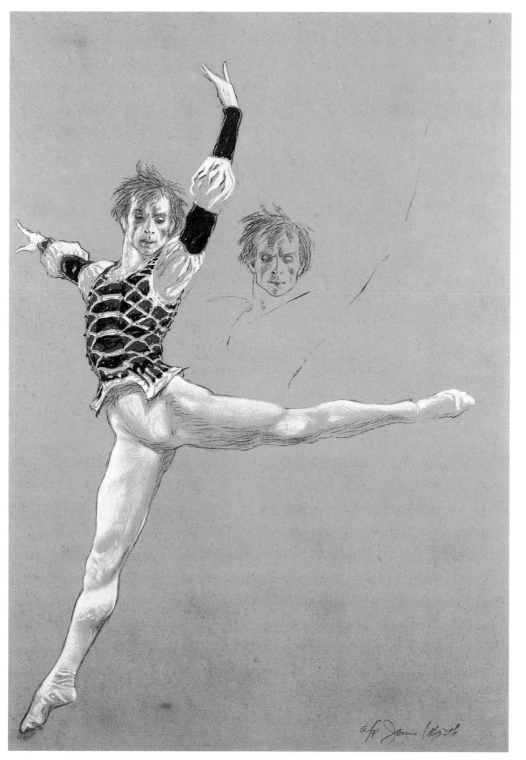

RUDOLF NUREYEV—LITHOGRAPH

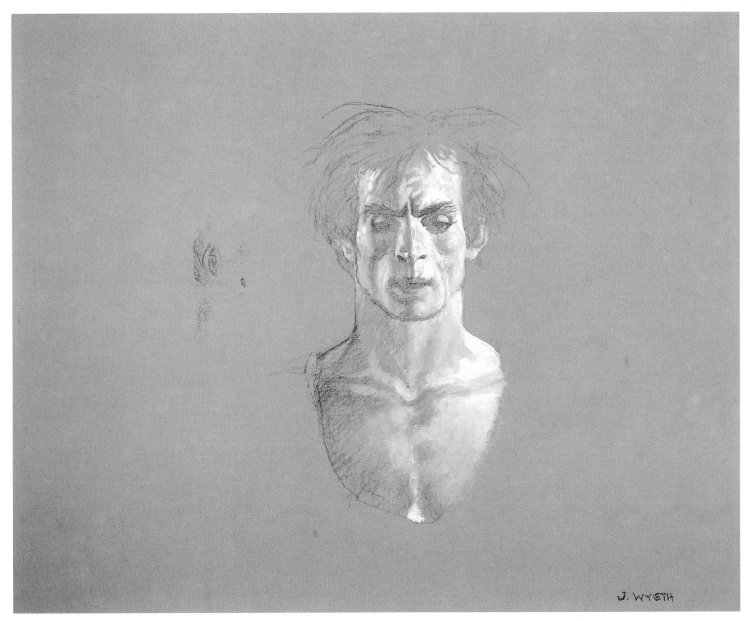

RUDOLF NUREYEV—STUDY #10

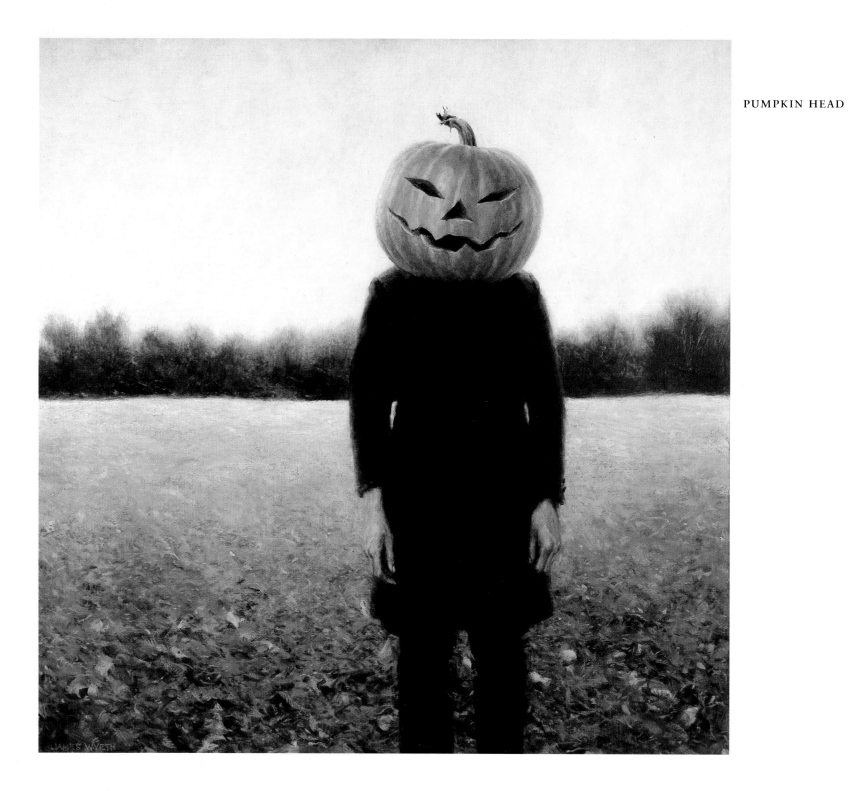

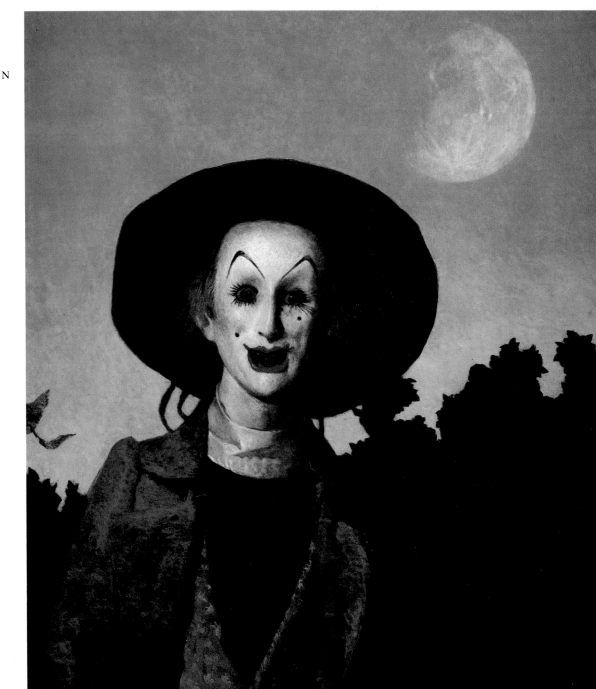

SHAPES

JAMIE WYETH'S strong sense of design was already visible in his earliest pen and ink drawings of knights and soldiers in combat, in which the shape of the table, the peaked roof of a thatched hut, or a banner hanging on a wall often dominated the life and death struggles that were going on. In so many of his paintings shown here, the buckets and kettles, pumpkins and bags, bunker-shaped cisterns, and pipe lengths seem to exist for the pure joy of their shapes.

The element of humor abounds in Jamie's paintings, but seldom more strongly than in the picture *Southampton*. Unlike the other paintings in this section—of objects Jamie found in his backyard at Chadds Ford or Monhegan Island, Maine— *Southampton* was inspired by a visit to that summer resort when he was a child. What caught the artist's attention and sense of humor was the contradiction he saw in people going to great lengths to get to the beach, only to take every precaution against being exposed to the sun. The oval "courting window" in the side of the high-backed wicker chair seems to say much about the formality of a world so alien to the Wyeths of Chadds Ford. Equally allusive is the painting *Angeload*. The namesake of the painting is the mutt of Monhegan, a dog with no pedigree and only one, white eye. Yet Jamie paints her with all the circumspection that a Sargent would bring to a blue-ribbon spaniel.

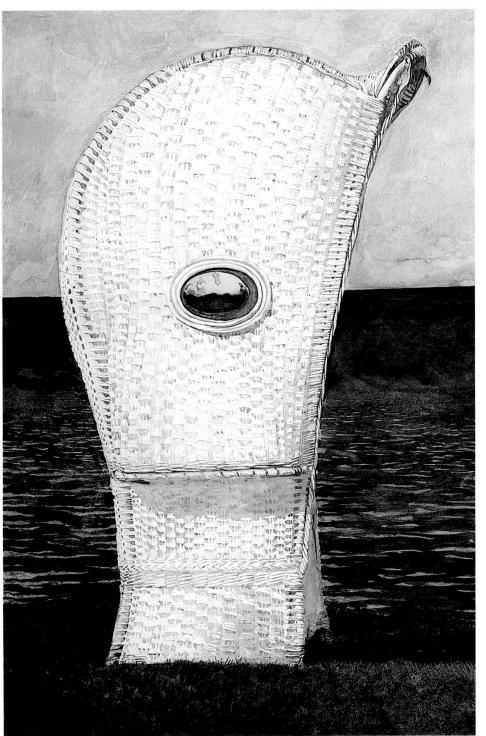

CORN CRIB

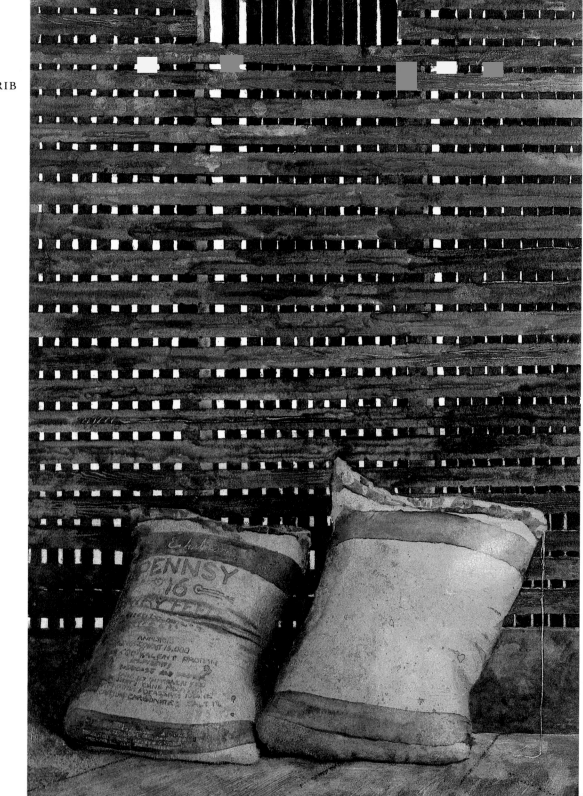

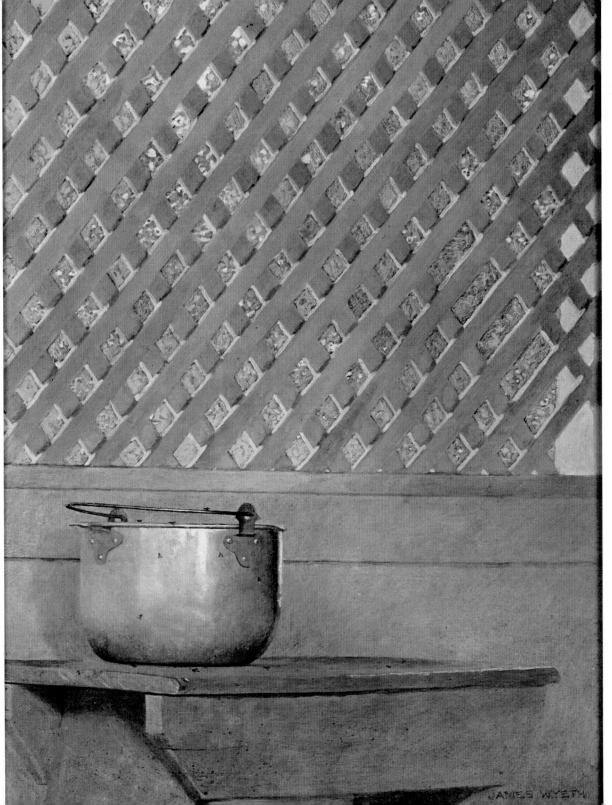

LATTICE WORK

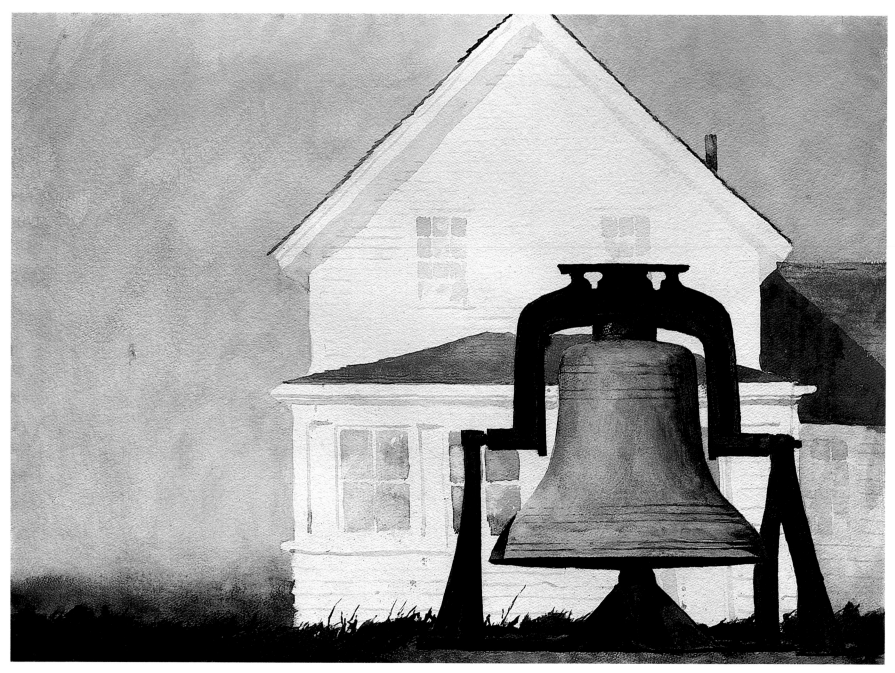

MONHEGAN BELL

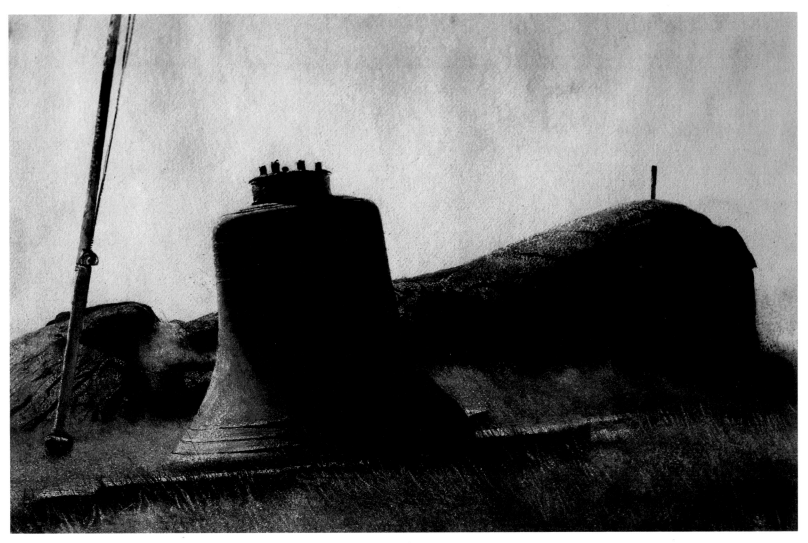

LANDMARK

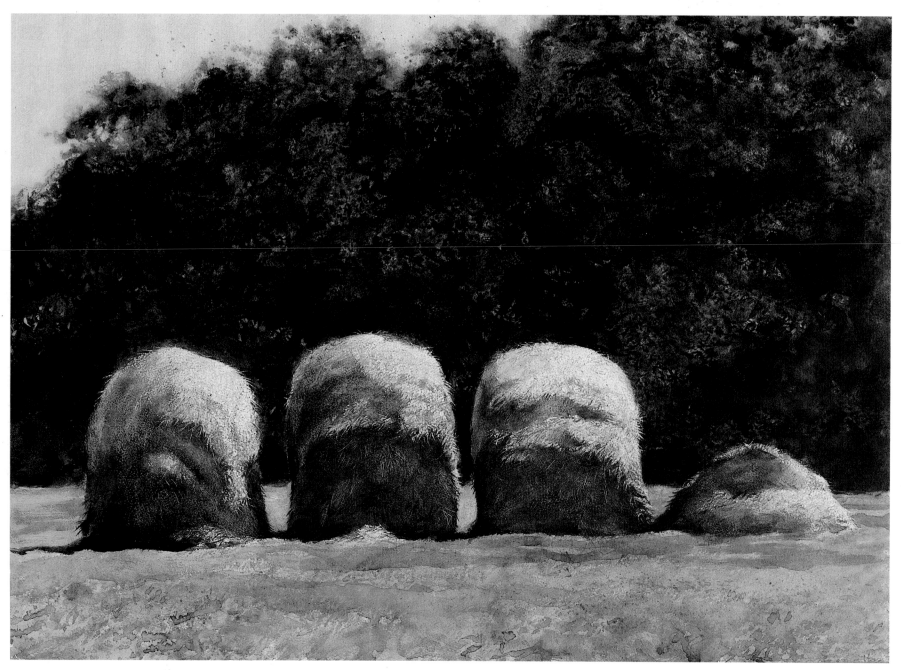

HAY LOAVES

BALF

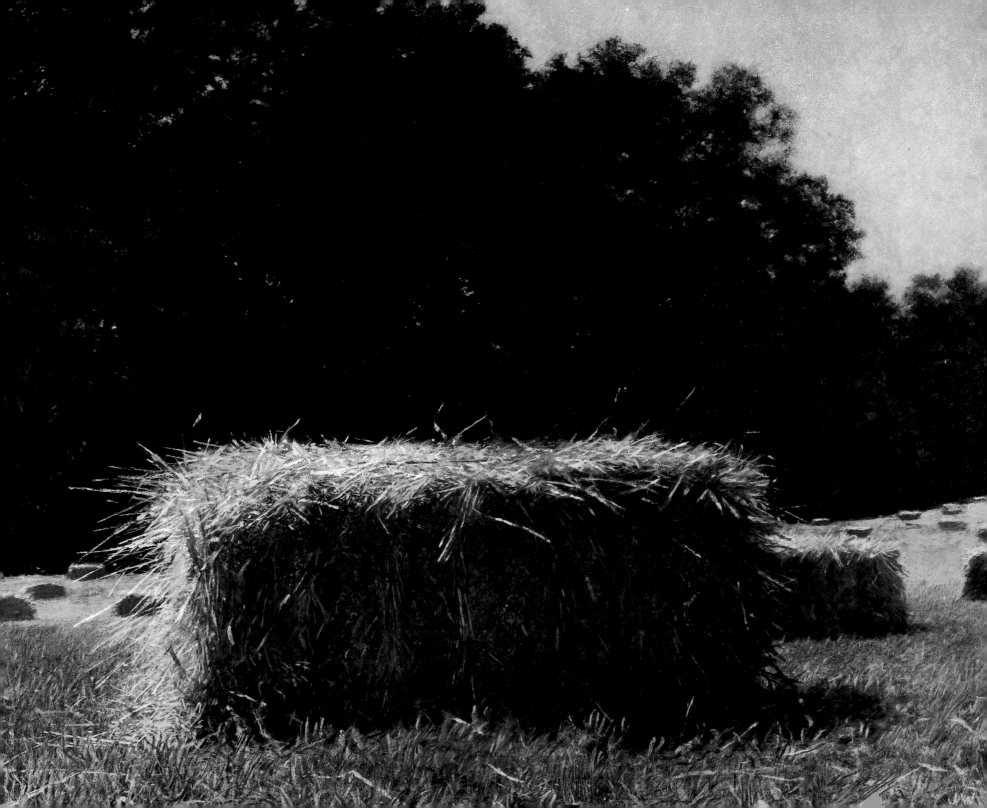

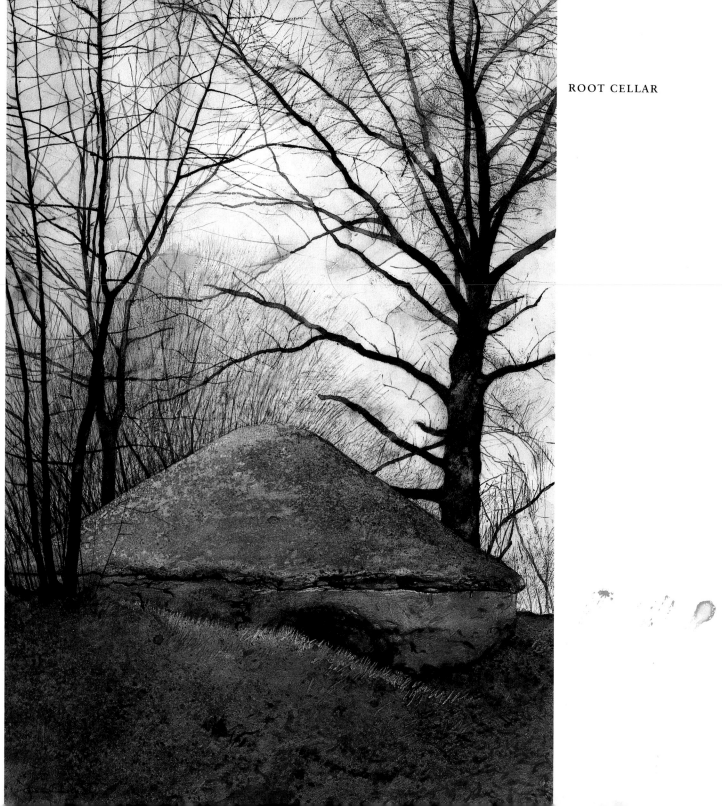

ROOT CELLAR

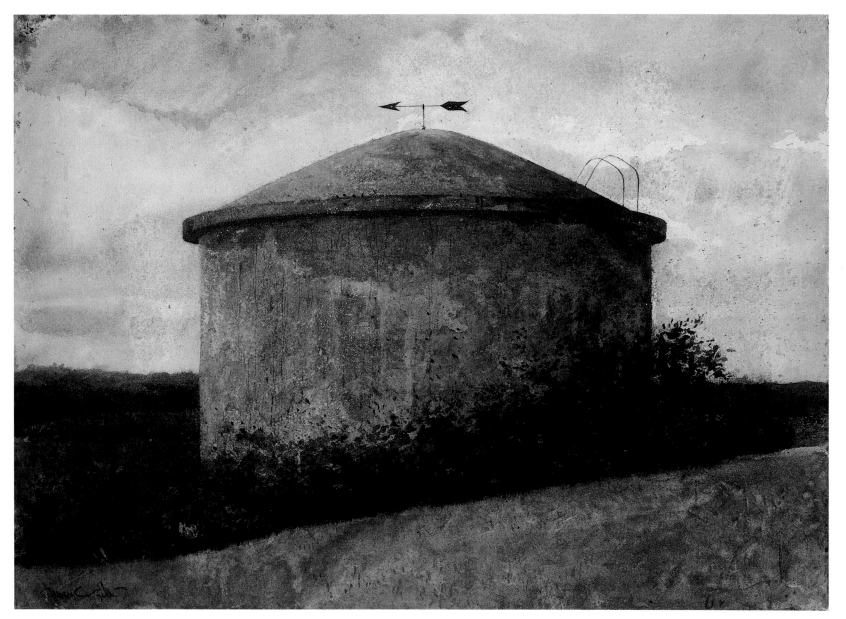

DUE NORTH

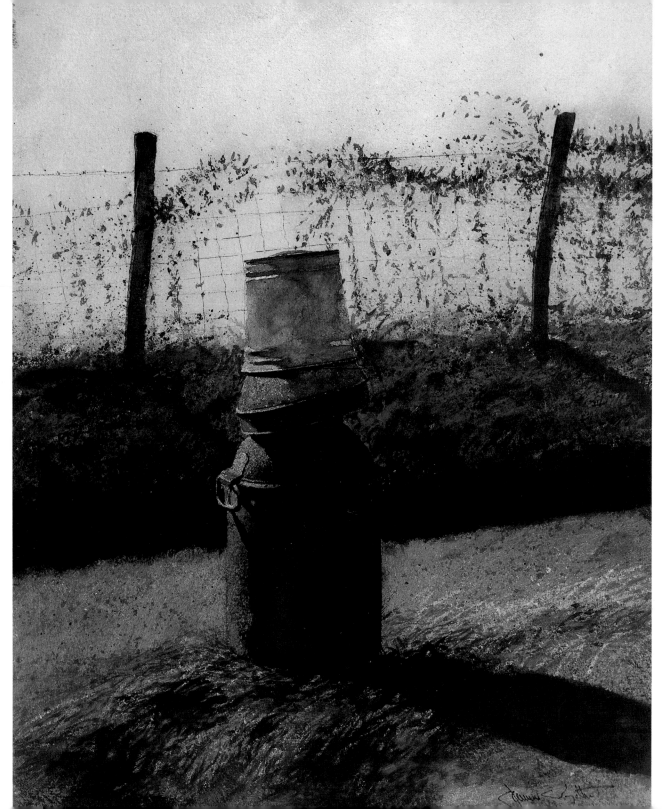

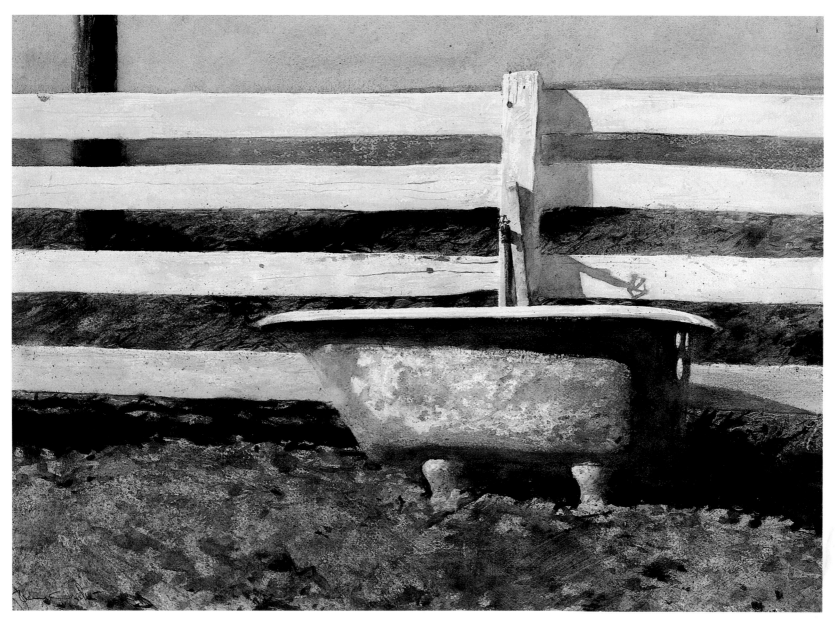

HORSE TUB

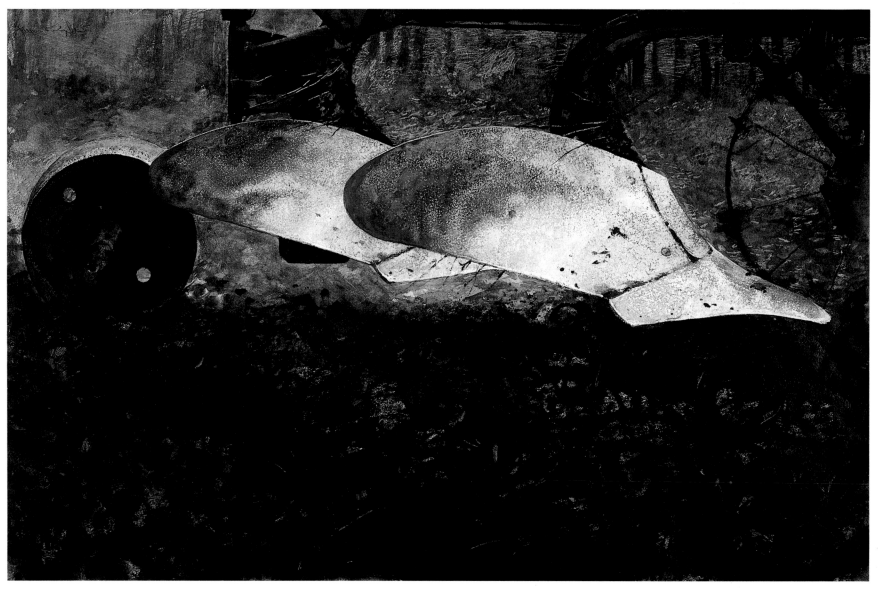

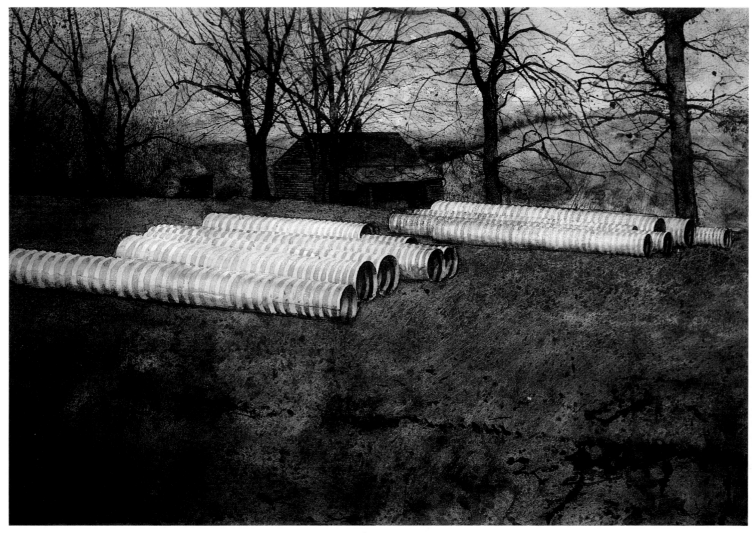

BIG INCH

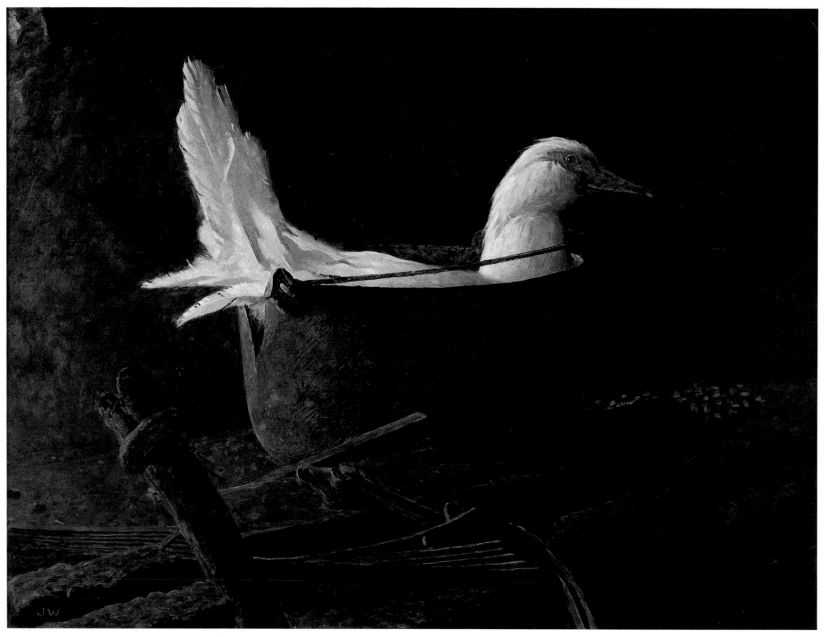

POT

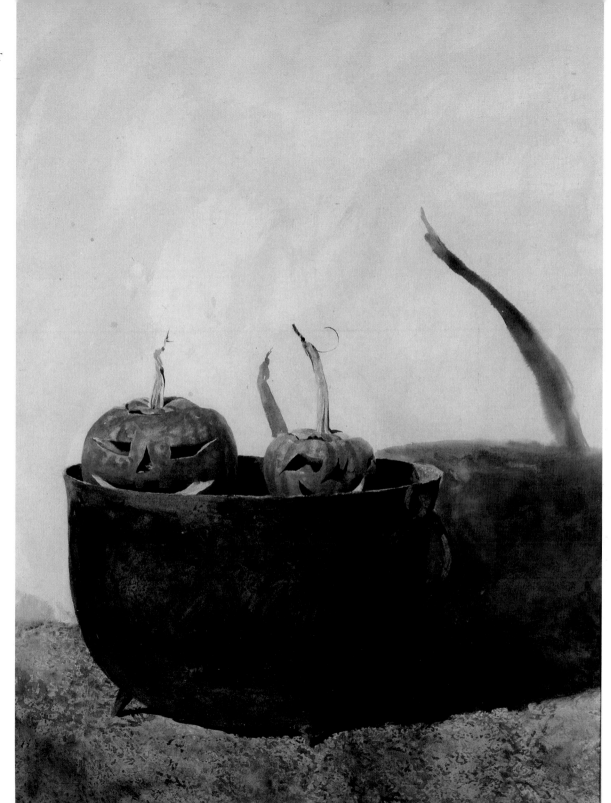

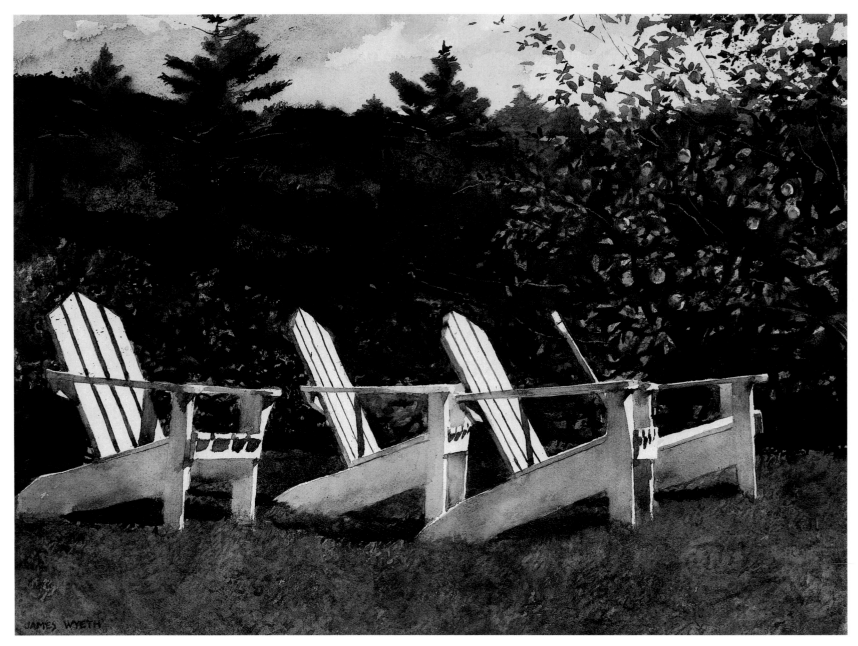

ISLAND LIBRARY

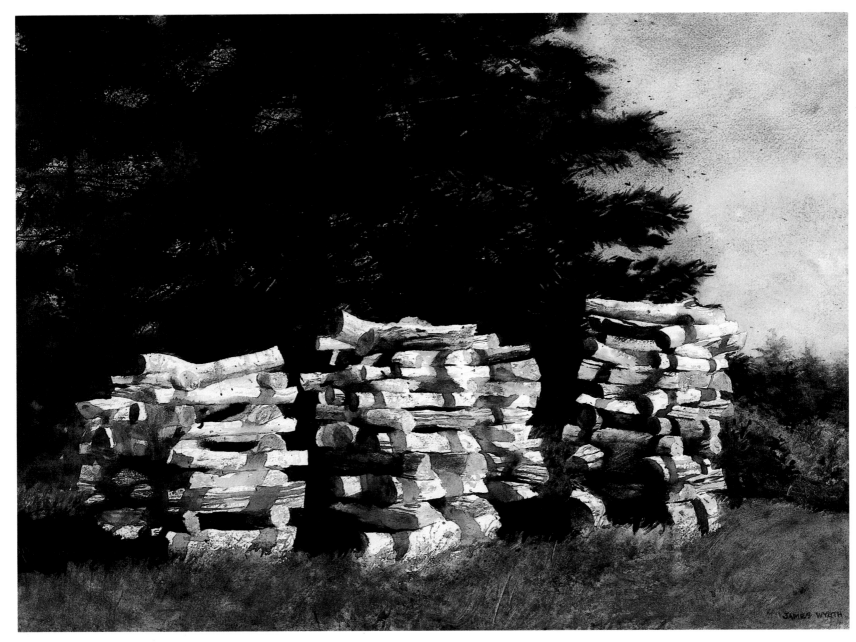

HALF CORD

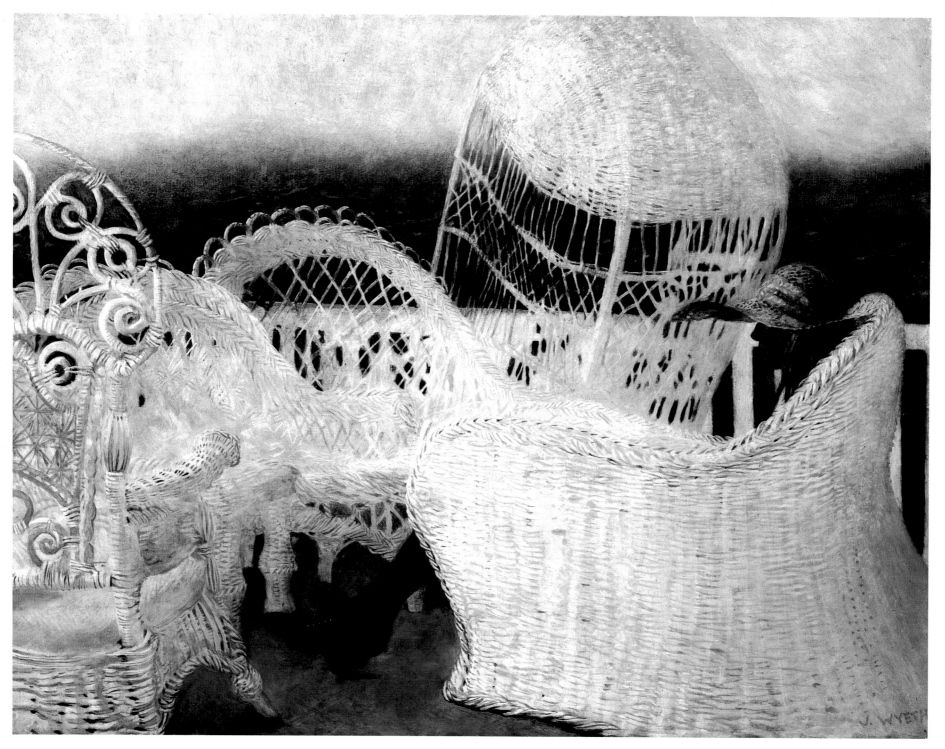

WICKER

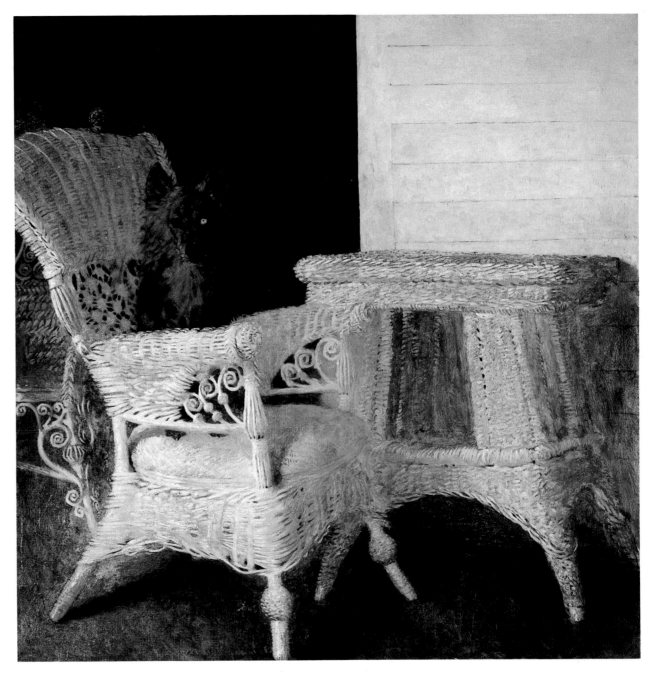

ANGELOAD

PIGS AND THINGS

AFTER LEAVING SCHOOL, Jamie discovered T. H. White's *The Once and Future King*, in which Merlin the Magician educates Arthur Pendragon by transforming him into a bird, a fish, an animal. The book meant everything to Jamie, who himself spent a solitary childhood with a private tutor and surrounded by animals.

During those Pendragon days, Jamie spent much of his time at Mattie Ball's farm near his parents' home in Chadds Ford, Pennsylvania. It was here that he first met Den Den, the big sow with the crooked snout, who was to become his favorite of all the barnyard pets. Life was very casual on the Ball farm, where all the animals were allowed to run freely.

When the sad day arrived that Mattie had to give up the farm, Jamie took responsibility for the animals, moving them to his own farm, Point Lookout, where he has lived since his marriage to Phyllis Mills in 1968. After a few territorial battles, the new animals learned to coexist happily with the Black Angus and thoroughbreds already in residence.

Jamie did not outgrow his love of animals. Instead he became ever more interested in their habits. He has kept a wolf in his living room, studied sharks in a specially built tank, and constructed a studio in his barn where he can hear raccoons scrambling across the false ceiling over his head.

All of the pictures in this section were painted at Point Lookout with the exception of *Pumpkin March*, which shows a neighbor's barn; *Mushroom Picker*, painted at Kennett Square, Pennsylvania; and *Whitewash*, which dates from the Mattie Ball farm days.

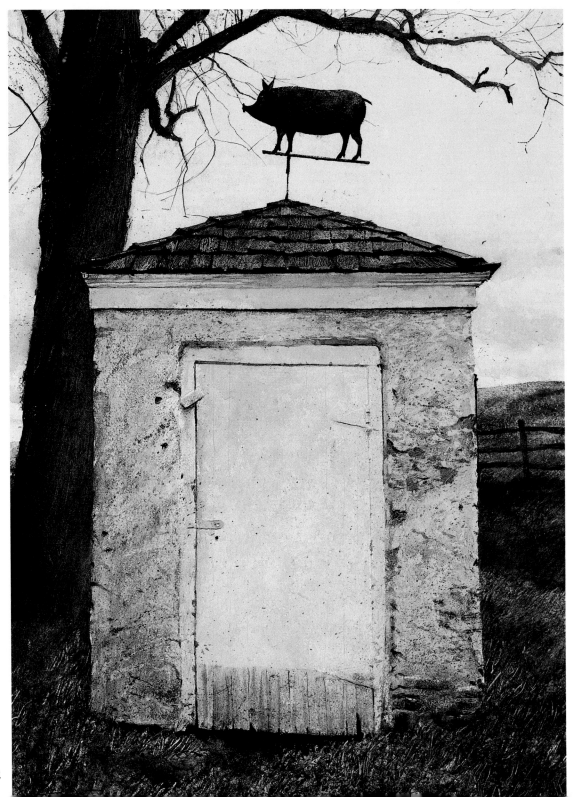

PIG HOUSE

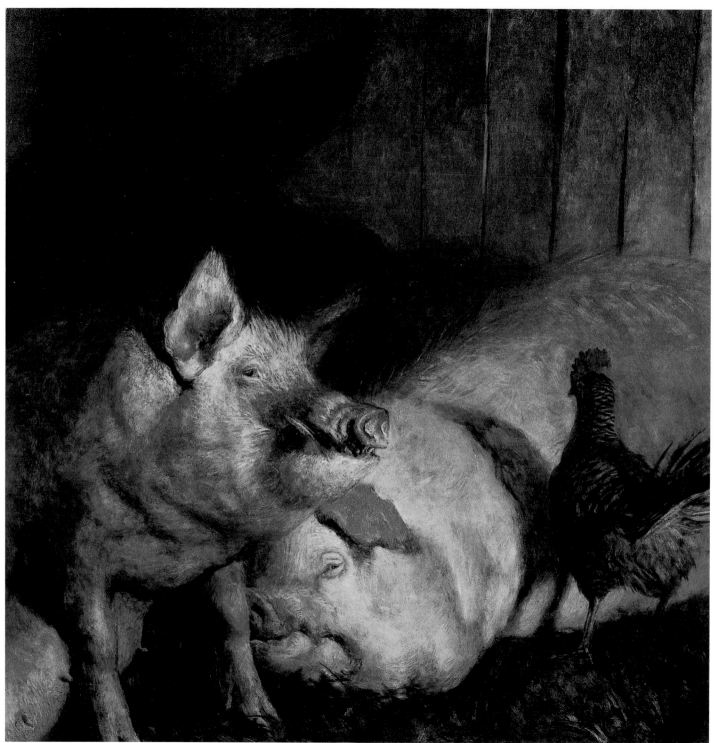

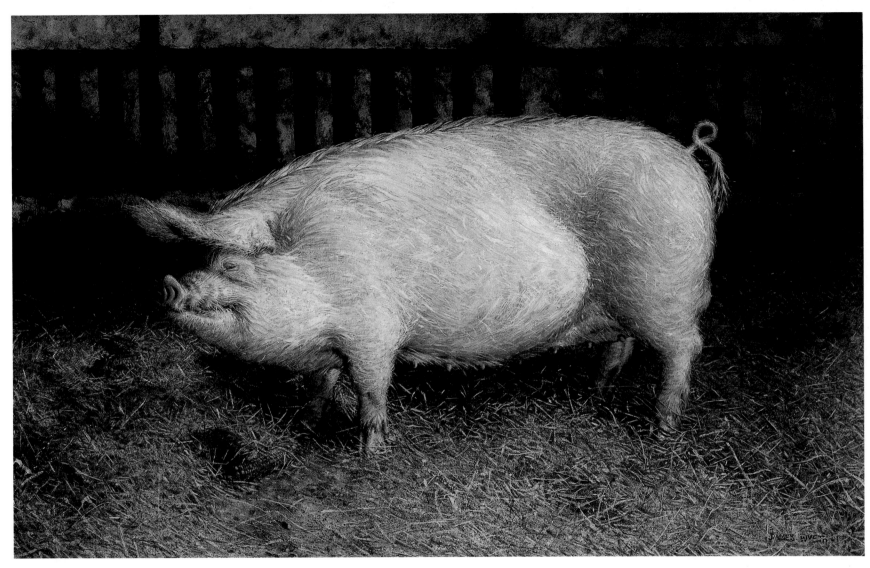

PORTRAIT OF PIG

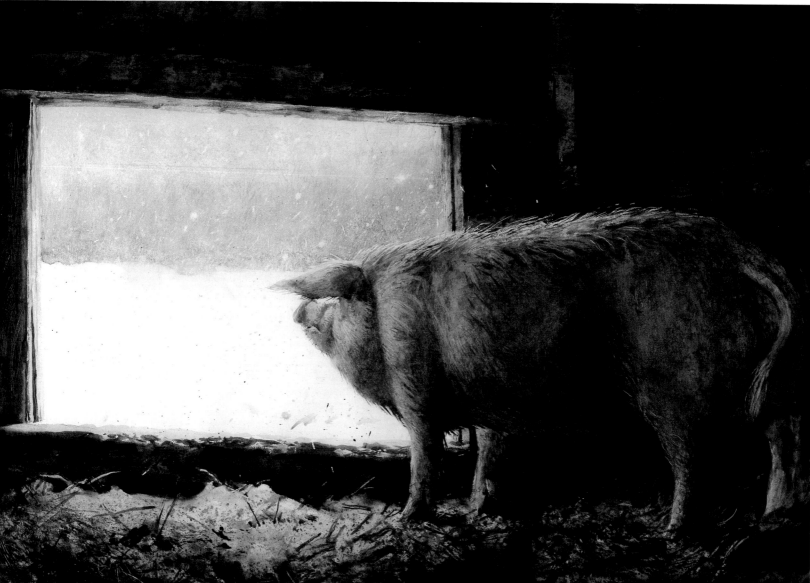

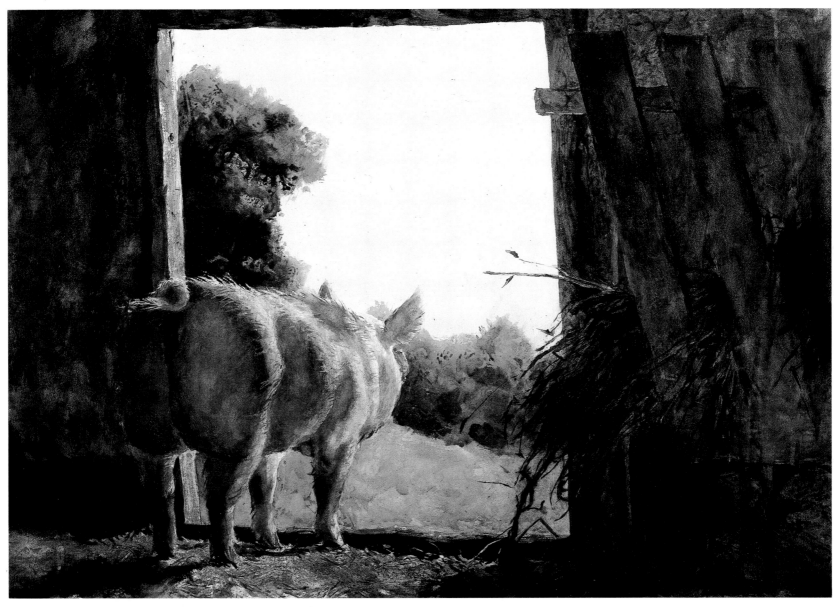

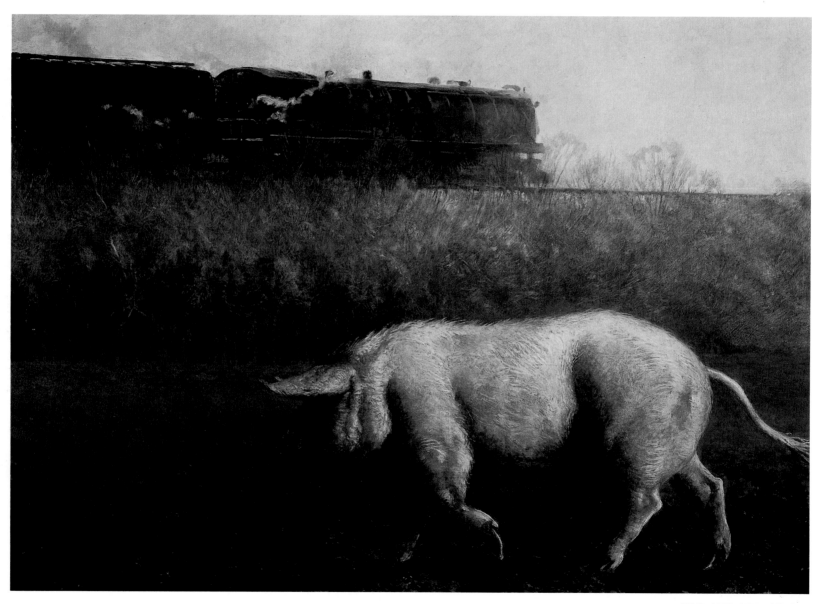

PIG AND THE TRAIN

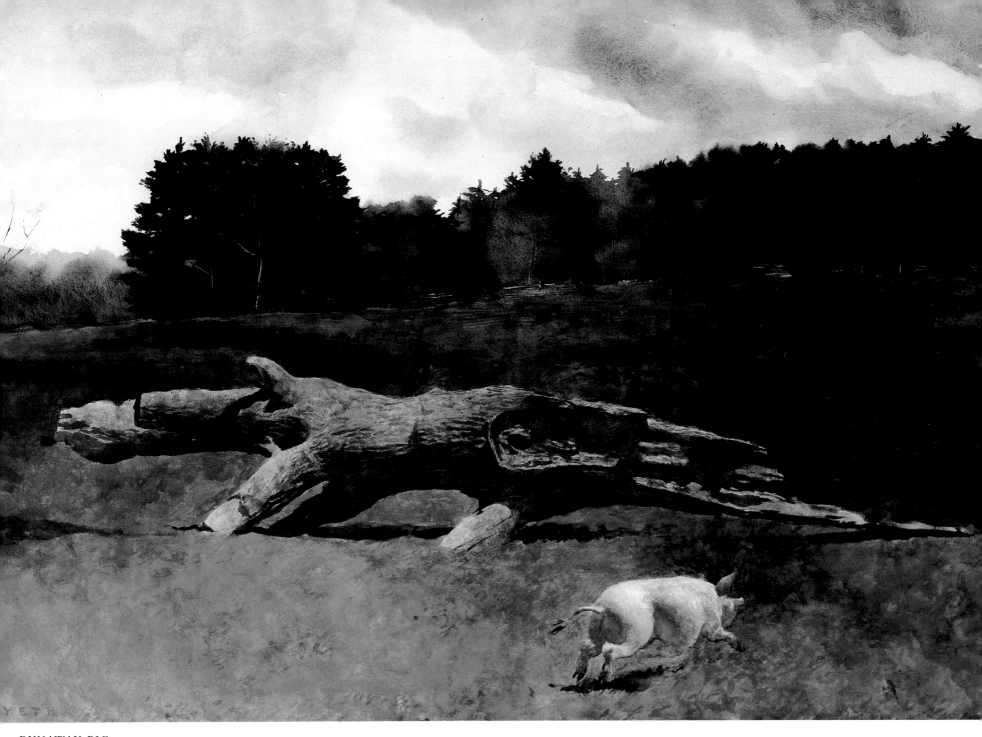

RUNAWAY PIG

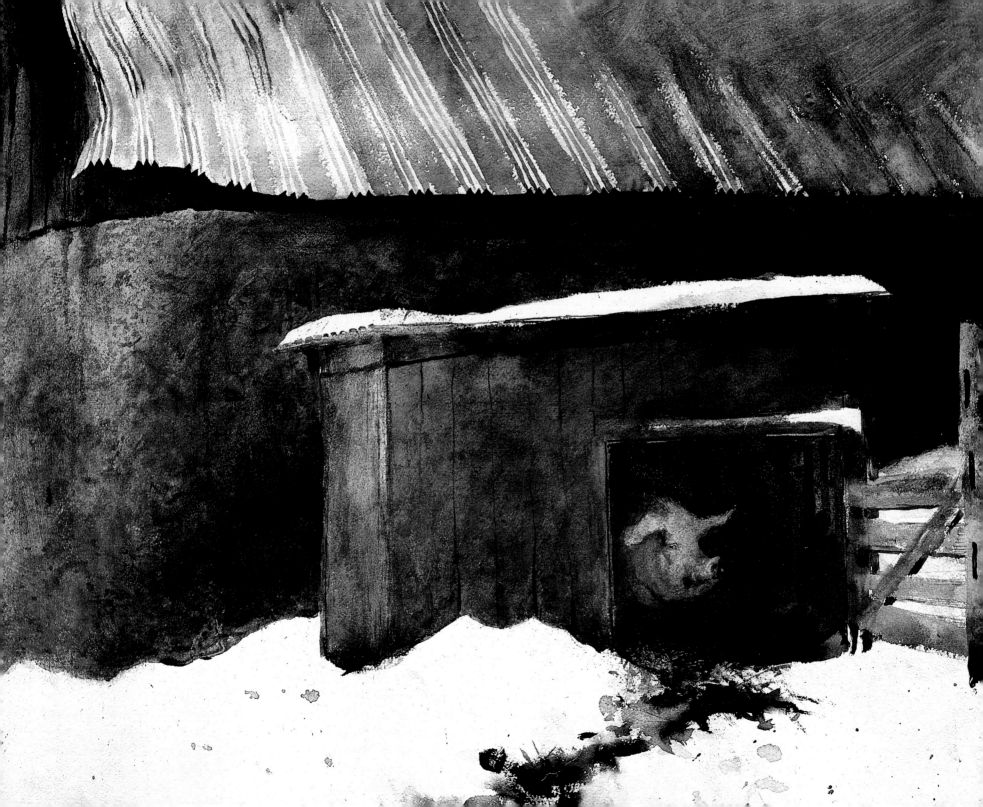

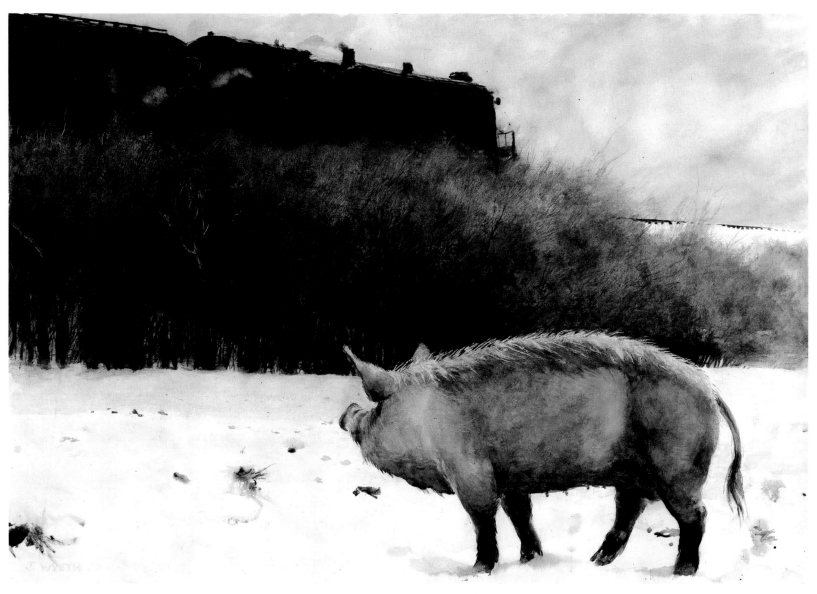

SWITCHER

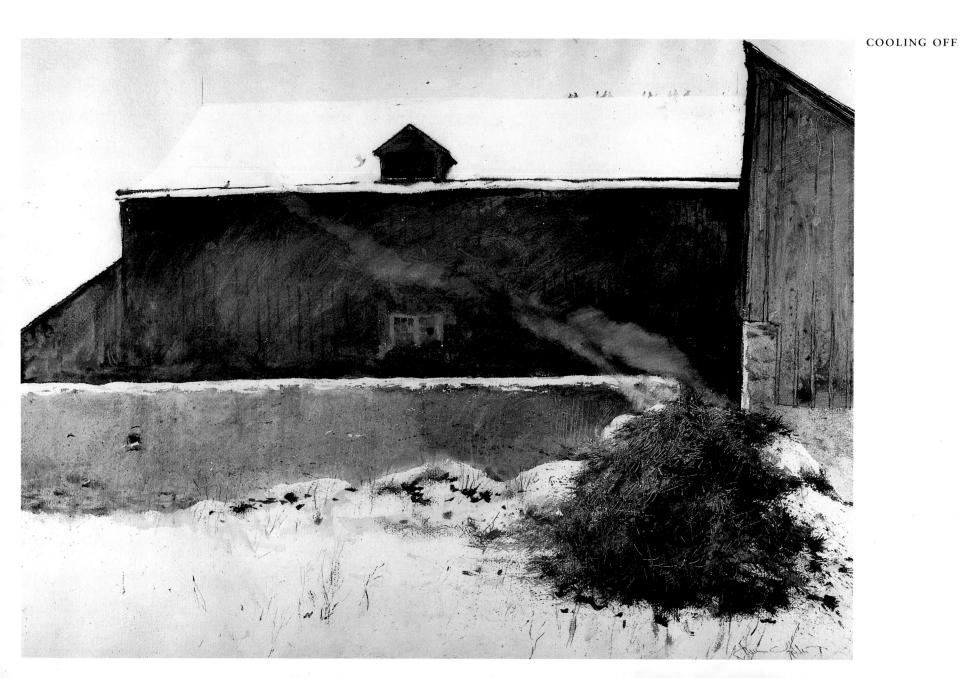

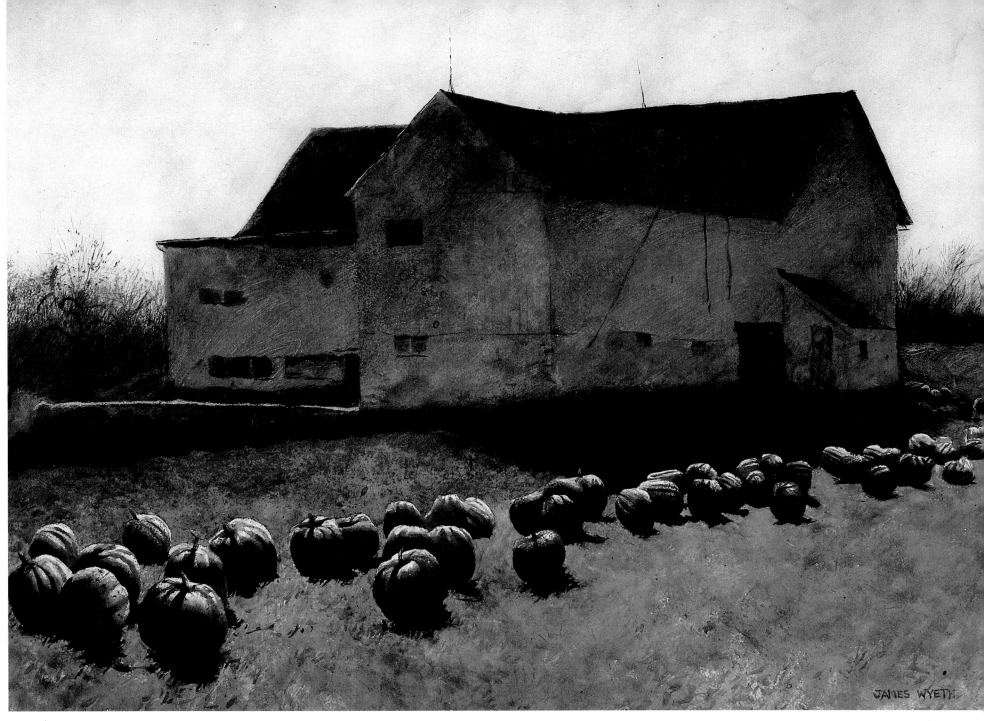

PUMPKIN MARCH

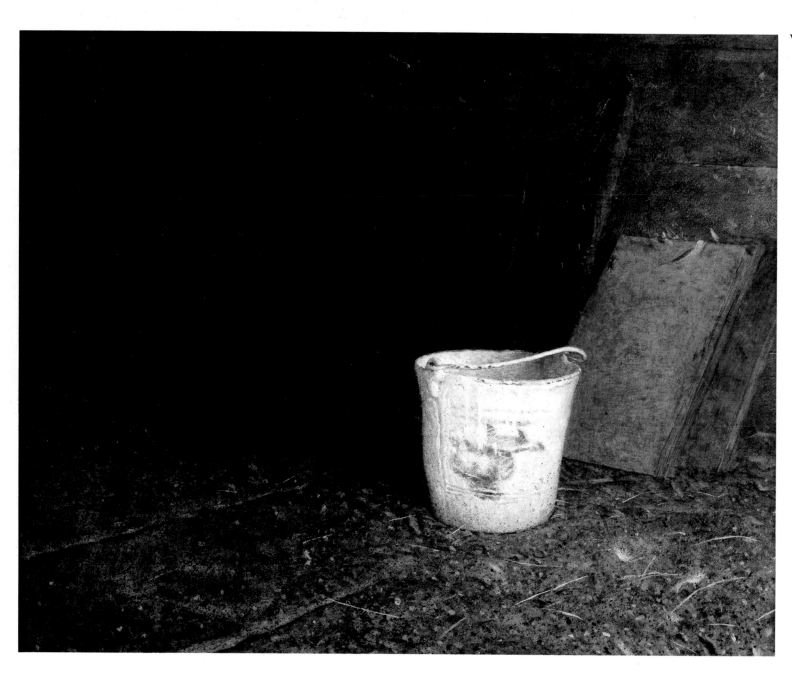

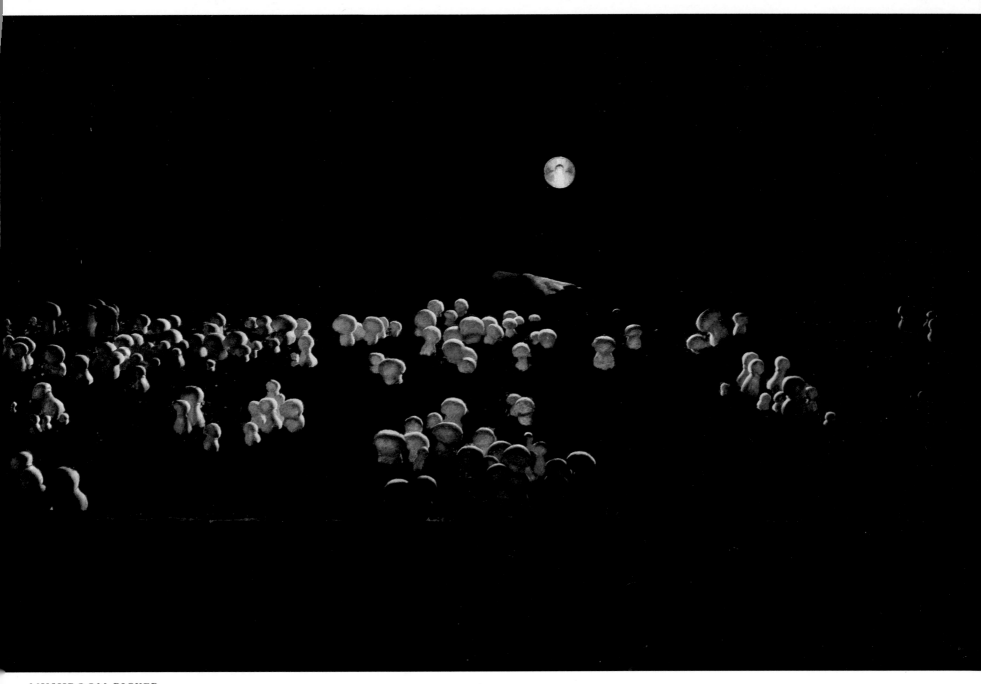

MUSHROOM PICKER

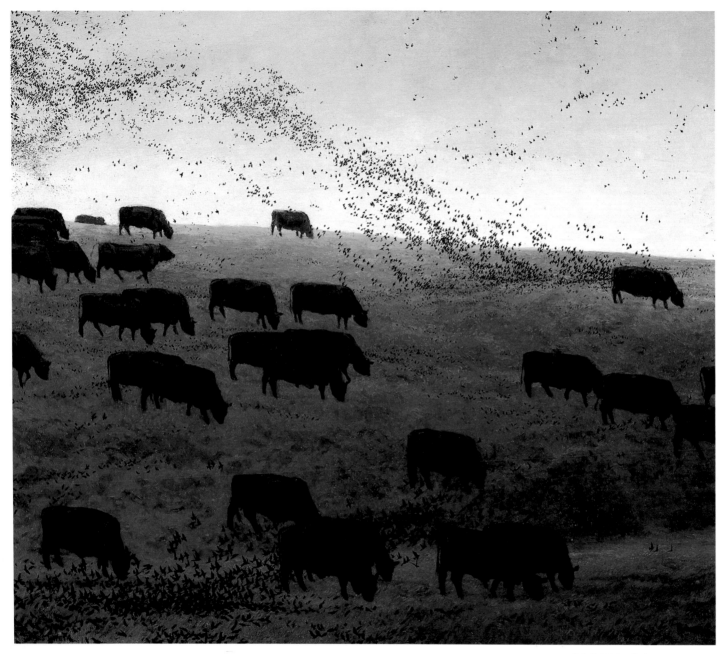

GRACKLES AND ANGUS

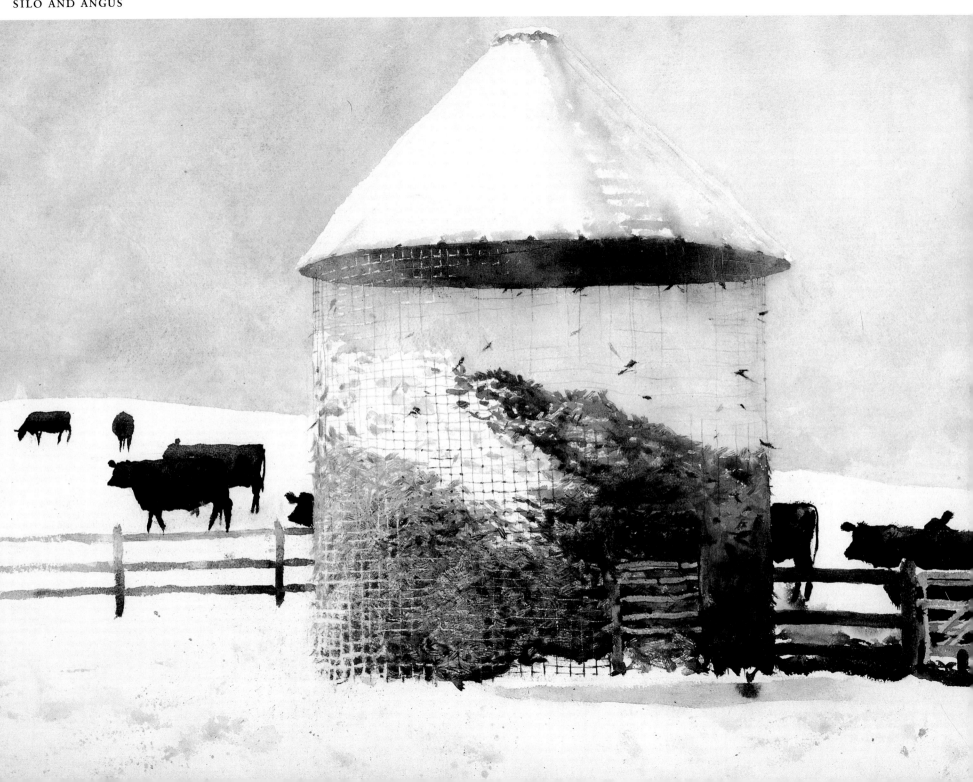

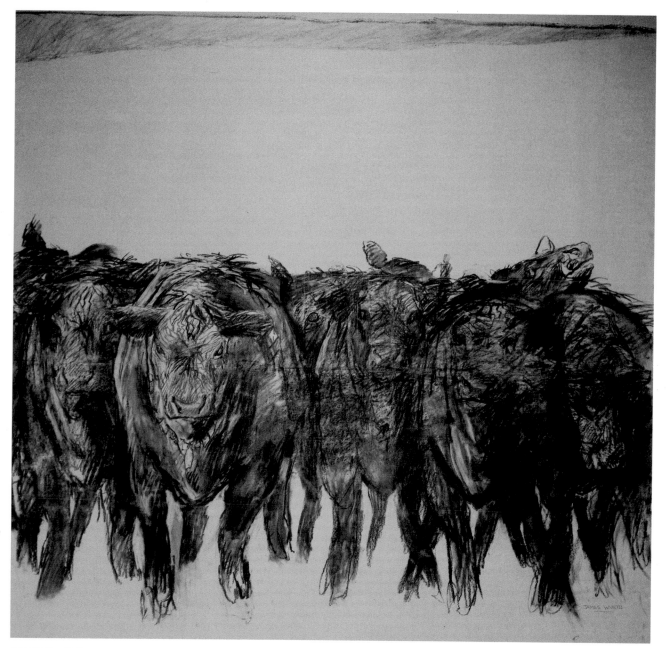

ANGUS—STUDY

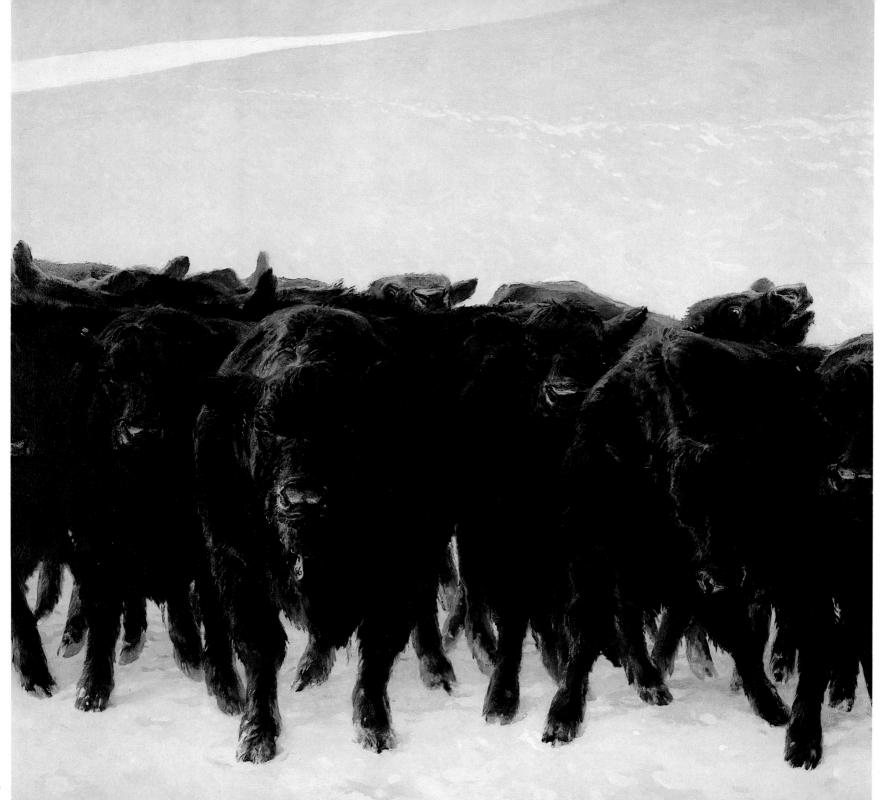

ANGUS

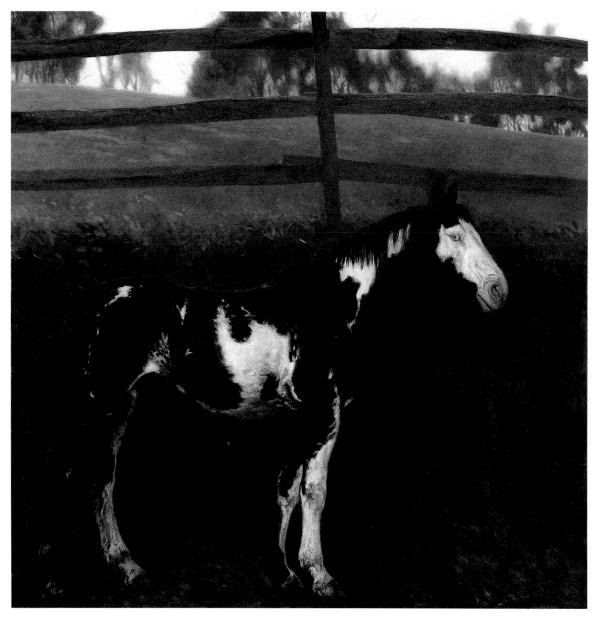

SKEWBALD

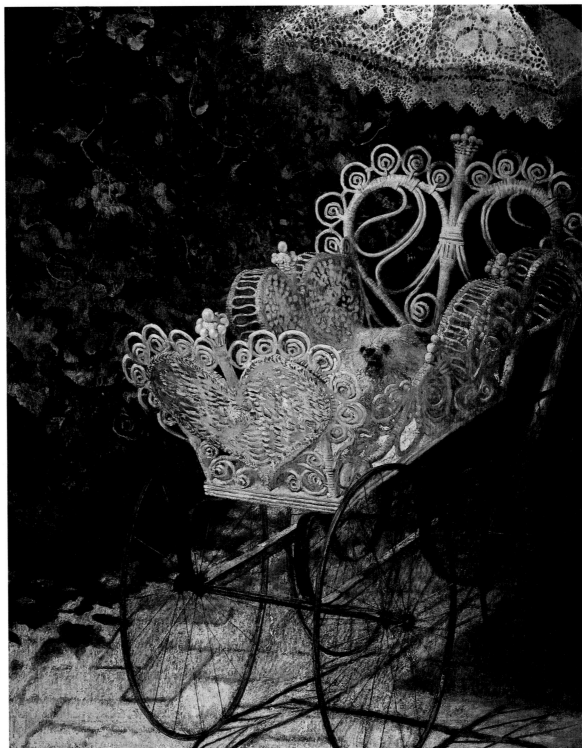

A VERY SMALL DOG

THE DEEP GORGE

THE WYETHS' FARM, Point Lookout, is named for a rocky ridge of land that crosses a major Indian trail and commands a sweeping view of the Brandywine River below. Towering oaks and walnut trees grow up the steep slopes, and fox dens are hidden in the rock outcroppings, while herds of deer leave the woods at night to feed in the fields on spilled corn.

When the ice on the river has melted and the last flood has roared down the valley, leaving uprooted trees, and the muddy cartroad has dried out, Phyllis Wyeth drives her ponies through one of the deep gorges that will bring her to the river bank where masses of Brandywine bluebells bloom in the spring.

Jamie knows every inch of this rolling country—has walked it, ridden it, canoed it, and, of course, painted it. What appeals to the naturalist in Jamie is not the far-off, idealized landscapes of sun-splashed meadows but the views from deeper in the woods and closer up. It's a vision of an irresistible force imposing its will— breaking through with fungus, root systems, split trunks. What emerges from these studies is a sense of a power of the life-and-death cycle at work, of shoots and buds, of funguses and decomposition, of both at once—the new growth springing up from the dead tree trunk.

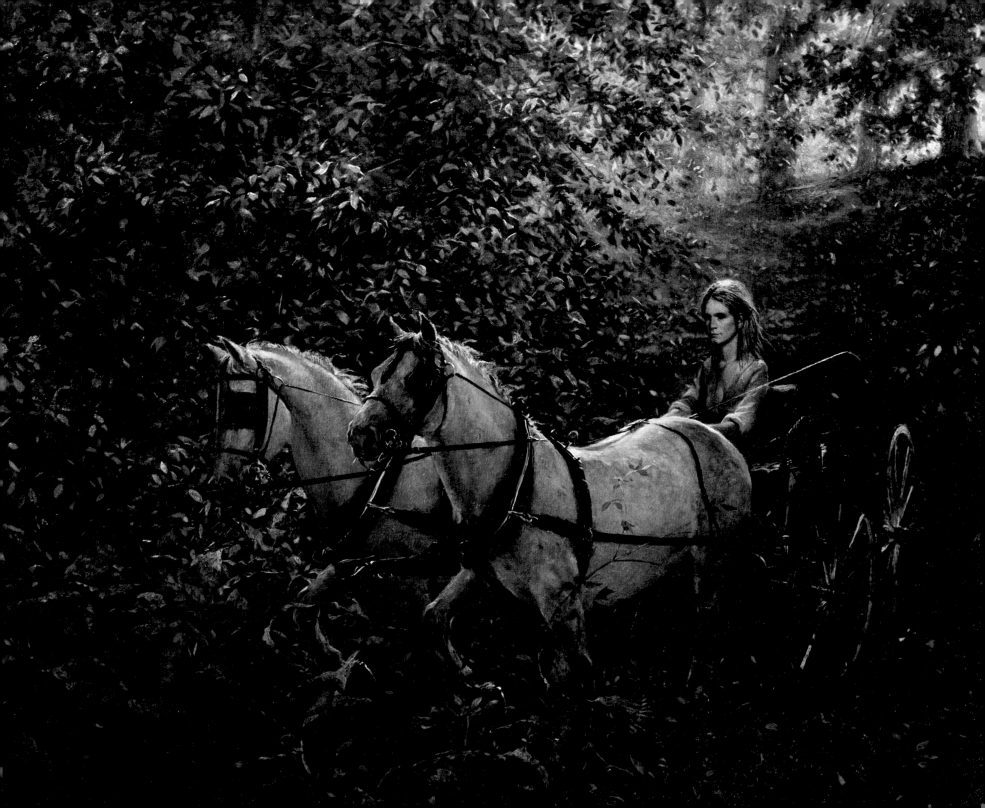

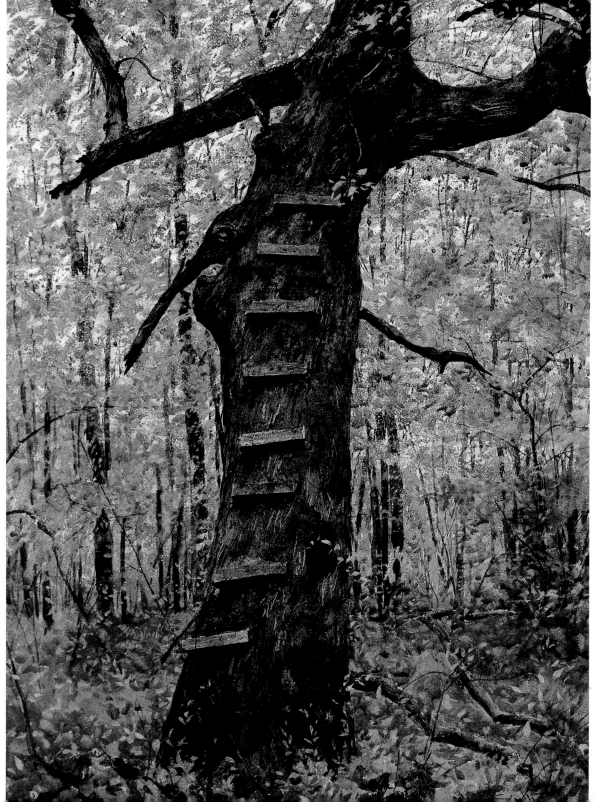

STEPS

ENGULFED

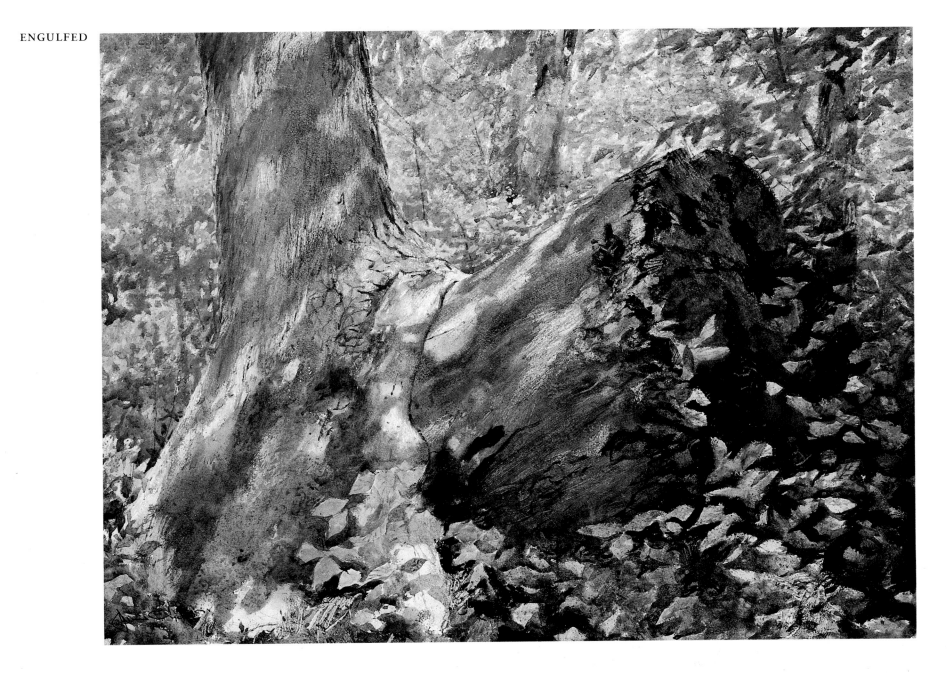

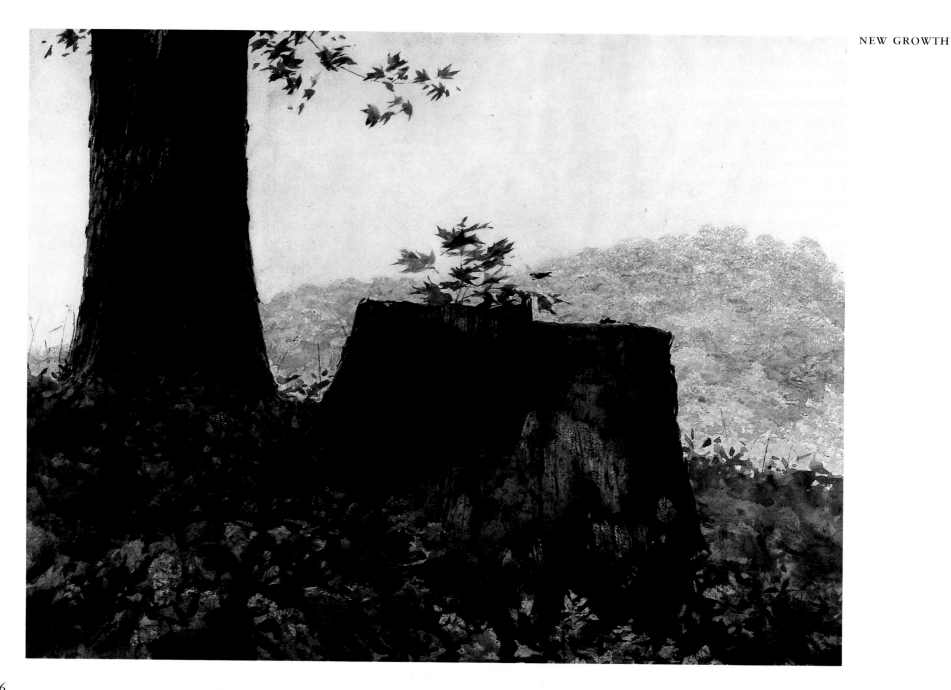

NEW SHOOT

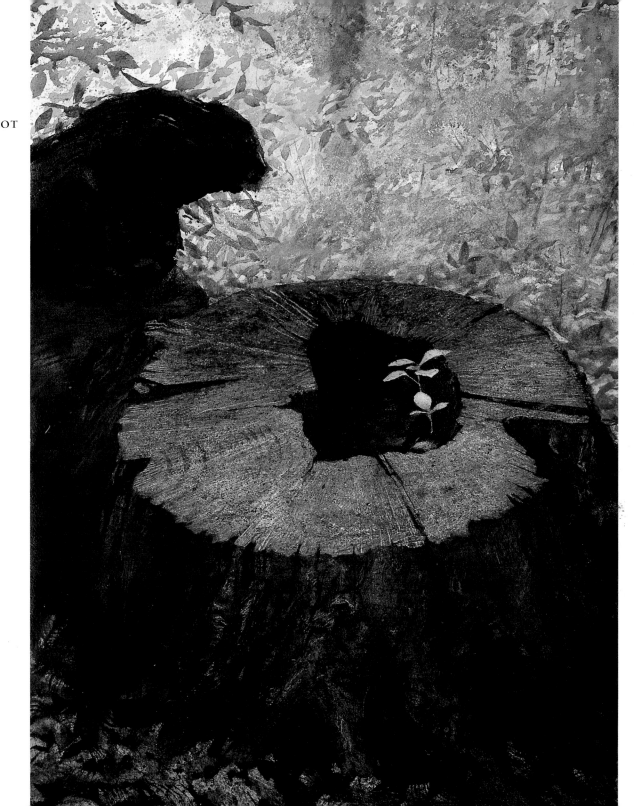

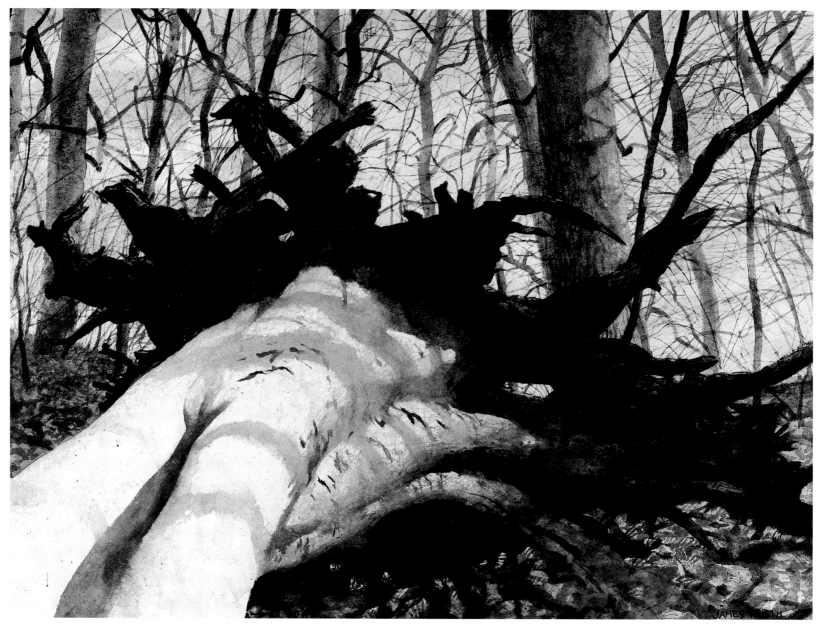

FALLEN

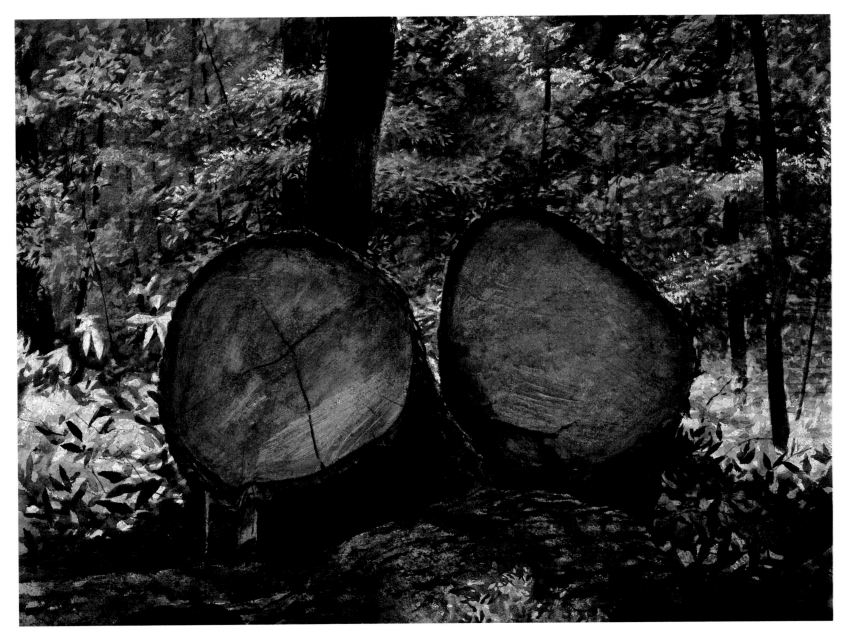

BUTTS

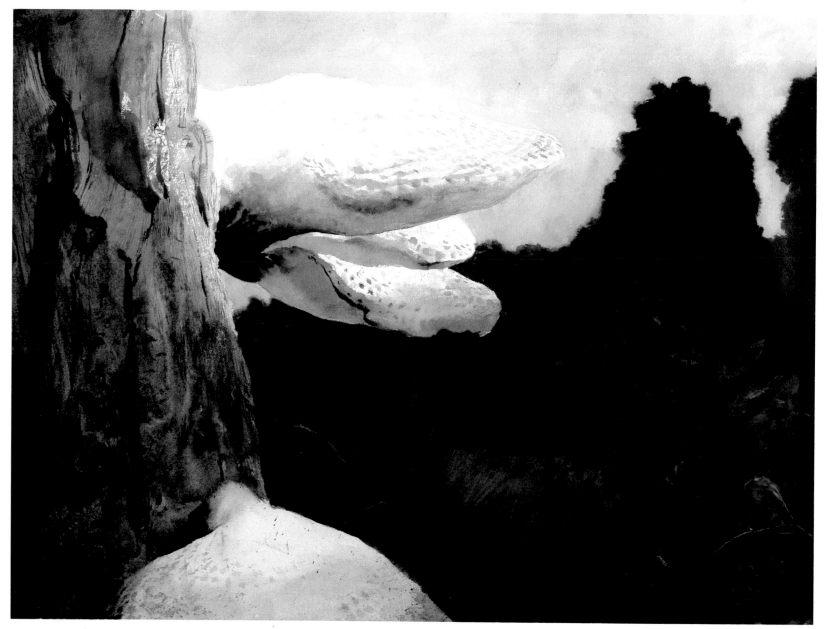

GIANT DRYADS

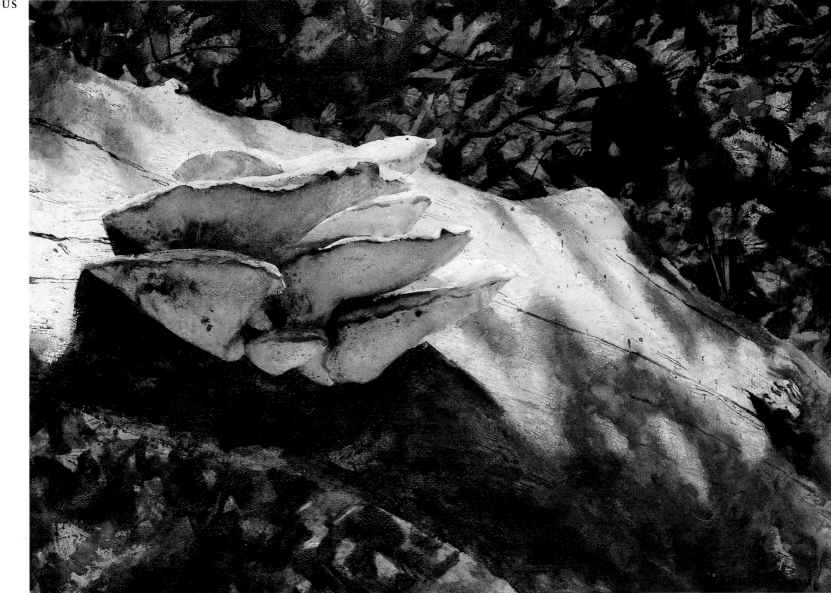

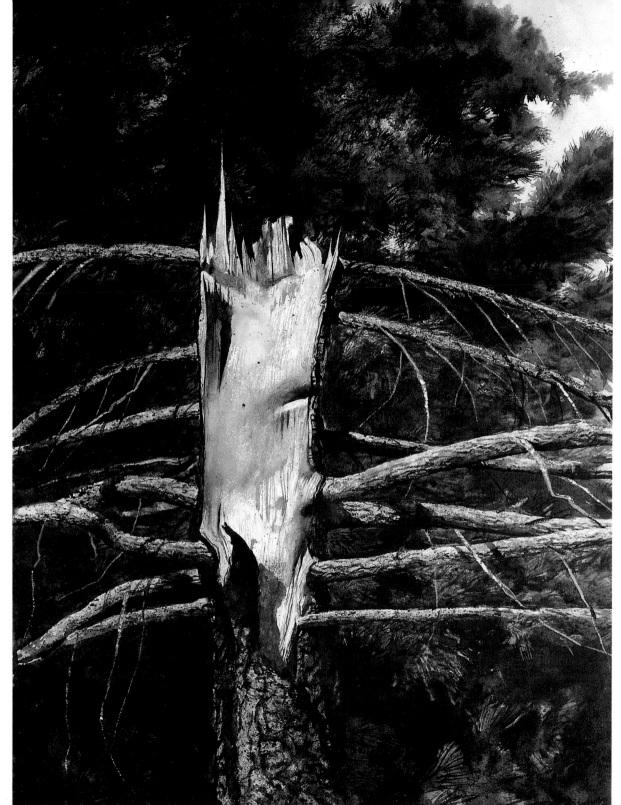

TORN SPRUCE

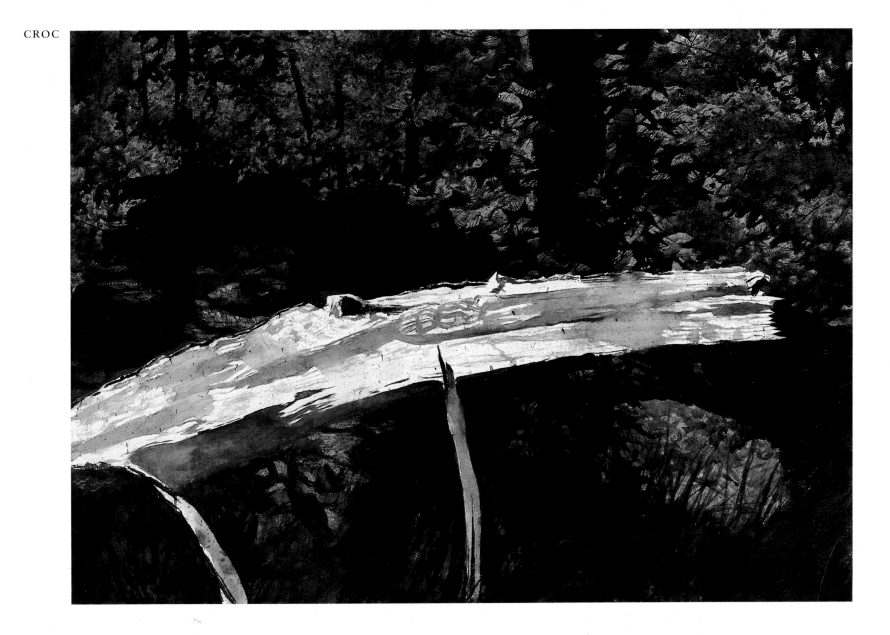

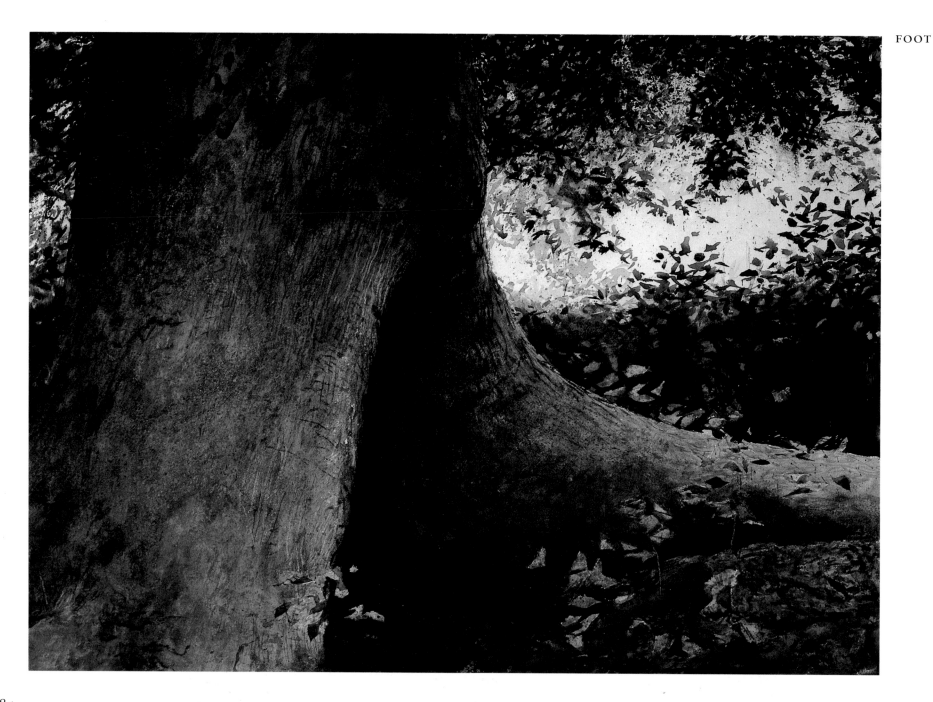

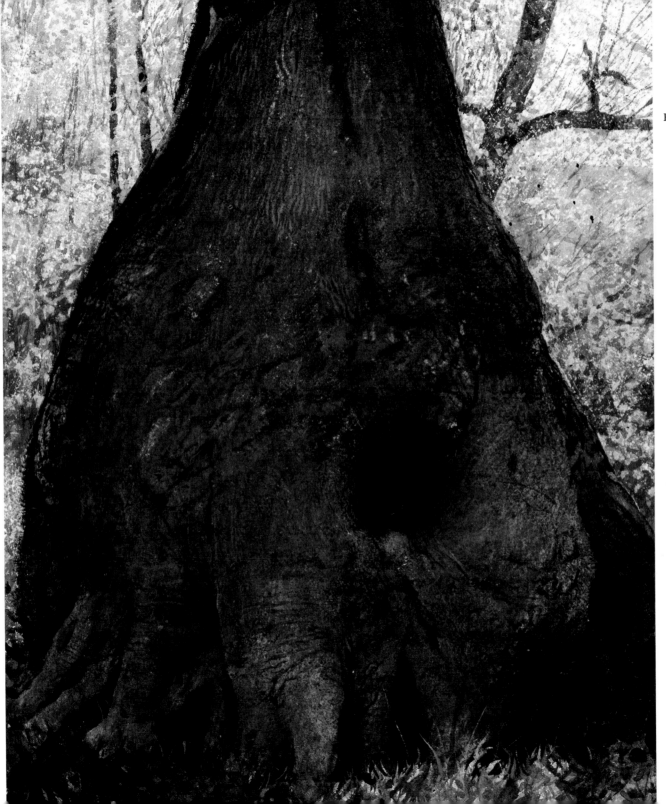

RIVER TRUNK

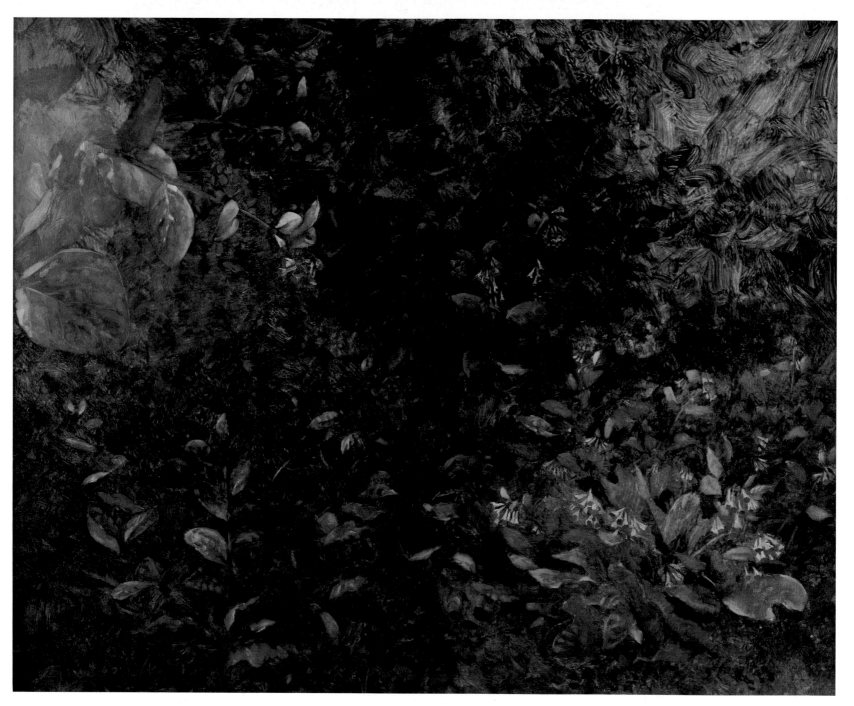

BRANDYWINE BLUEBELLS

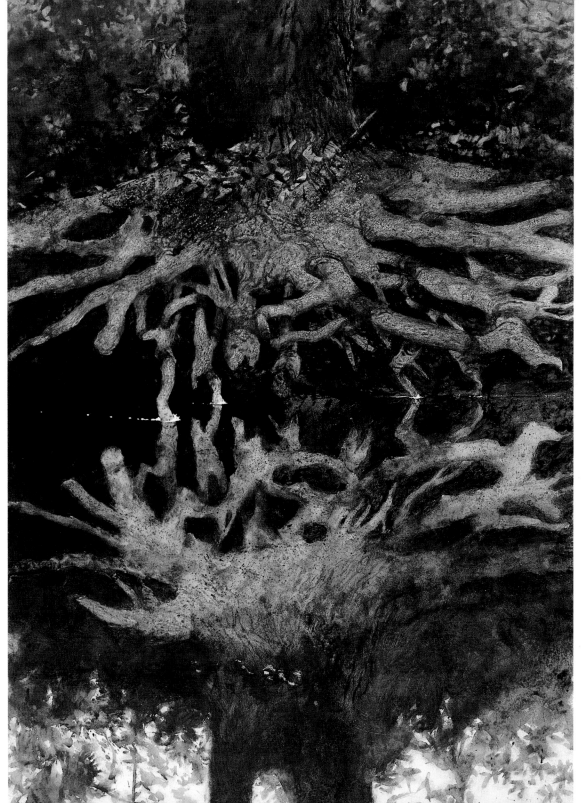

WHERE W. RAT LIVES

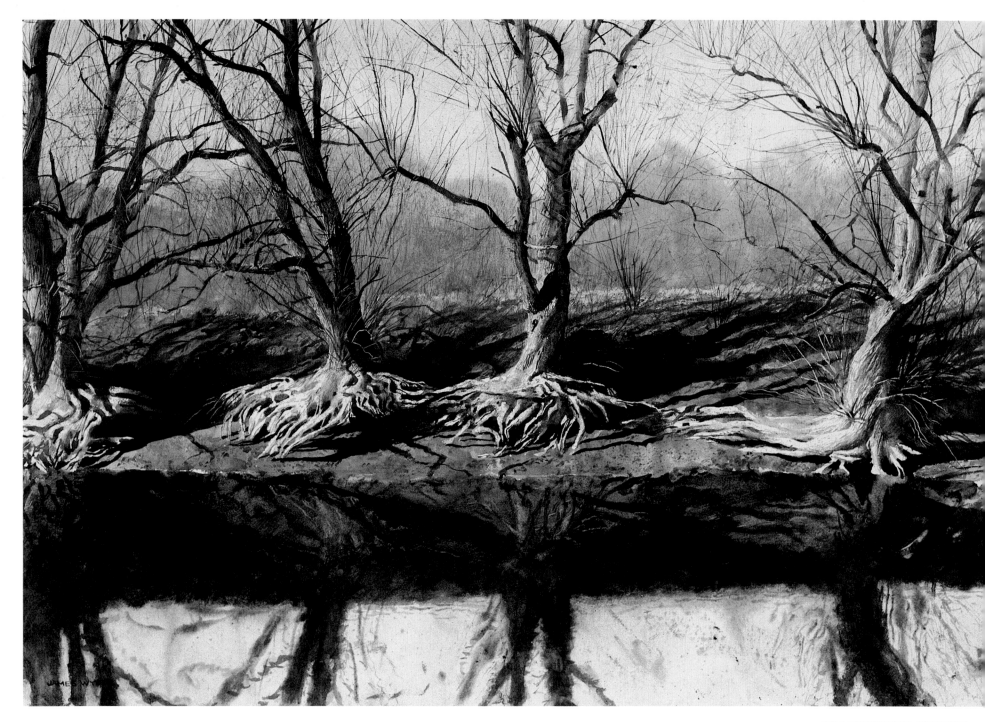

BRANDYWINE SPIDERS

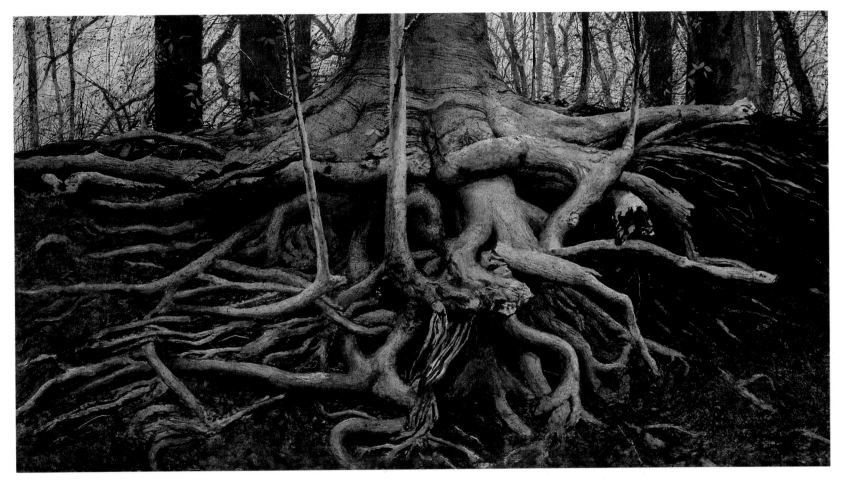

ROOTS

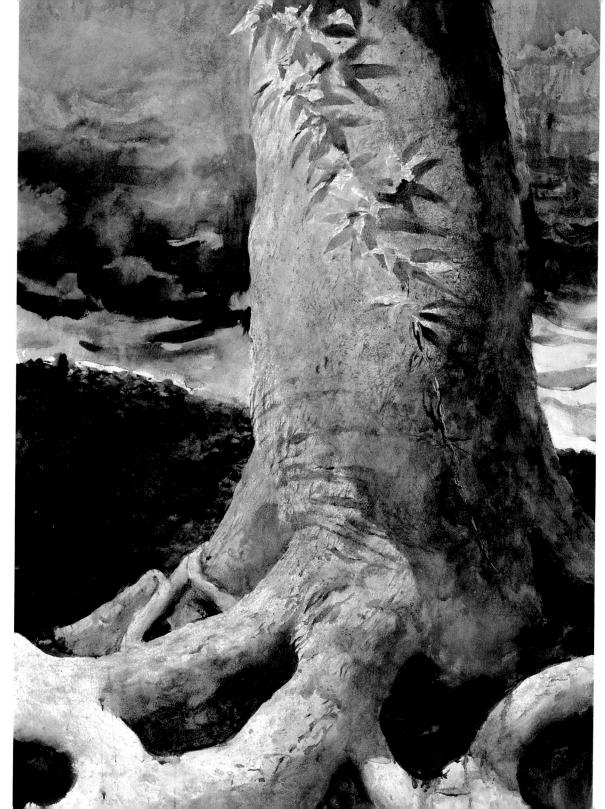

MUDDY WATERS

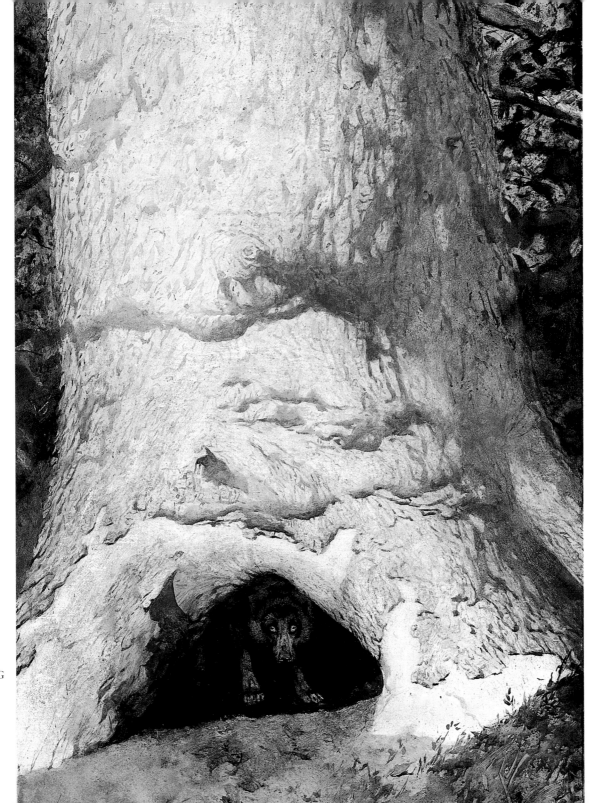

TREE DOG

MONHEGAN ISLAND

MAINE HAS BEEN the traditional summer home for the Wyeth family ever since N. C. Wyeth arrived at Port Clyde in 1916. His son Andrew settled in nearby Cushing, Maine, as a young man, and Jamie moved into Rockwell Kent's old house on Monhegan Island in 1968. Ten miles due east from the coastal towns of Cushing and Port Clyde, Monhegan is 600 acres of rocks and forest rising out of the North Atlantic. With no central electricity and no cars, Monhegan is a refreshing throwback to a more self-sufficient age.

Most of the houses were built before 1930, and several of them were designed by Rockwell Kent himself. They were constructed to withstand the ravages not only of time but also of the sea, with shingle or lapstrake siding and foundations anchored to the very rocks themselves. The designs and rooflines of the houses are unique, and some are positively bizarre. Kent once wrote Jamie Wyeth that among the less fortunate monuments he had left on the island were the two houses that mirrored each other exactly, inside and out (see *Twin Houses*).

There are two Monhegans in reality, the island of houses open to the summer sun and the island shuttered up against winter gales. The summer residents and day trippers see an island of dazzling white sheets blowing in the wind, and small beds of brilliantly colored flowers bordering well-worn footpaths. But the year-round residents know a different island, one of drained water pipes, mothballed houses, and a meager existence eked out from Maine's icy and unforgiving waters.

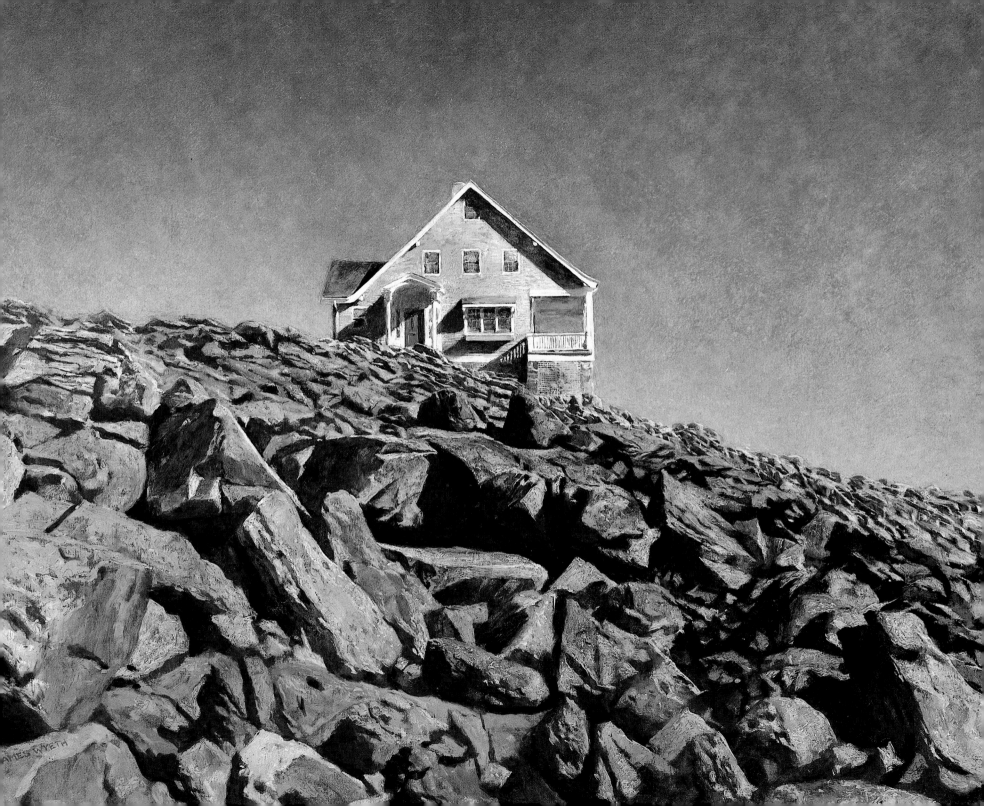

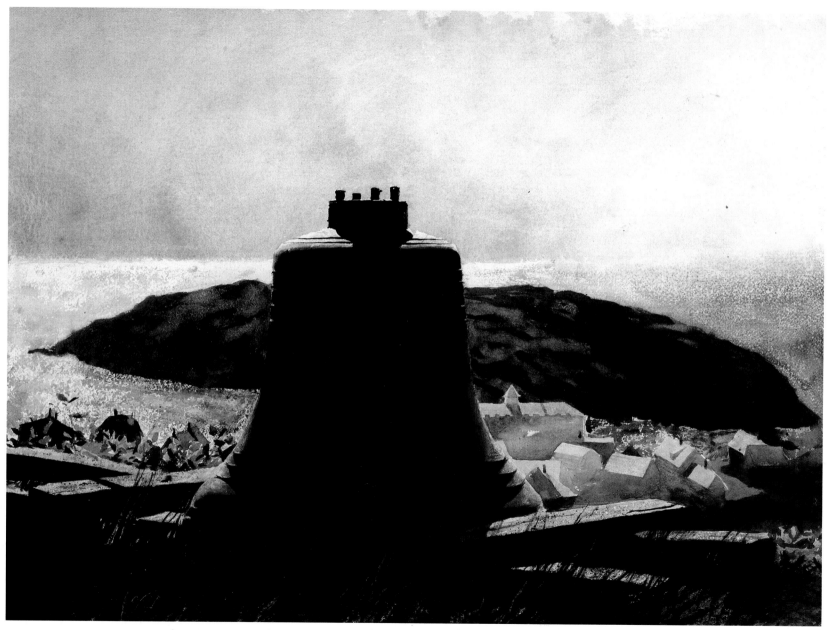

OBELISK

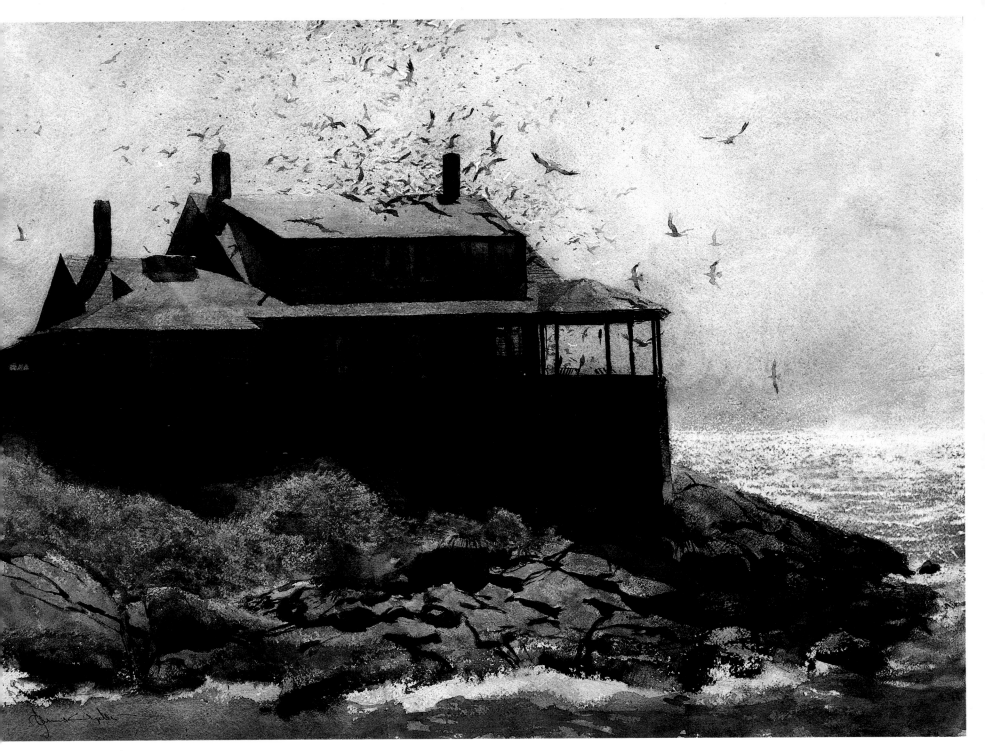

THE RED HOUSE

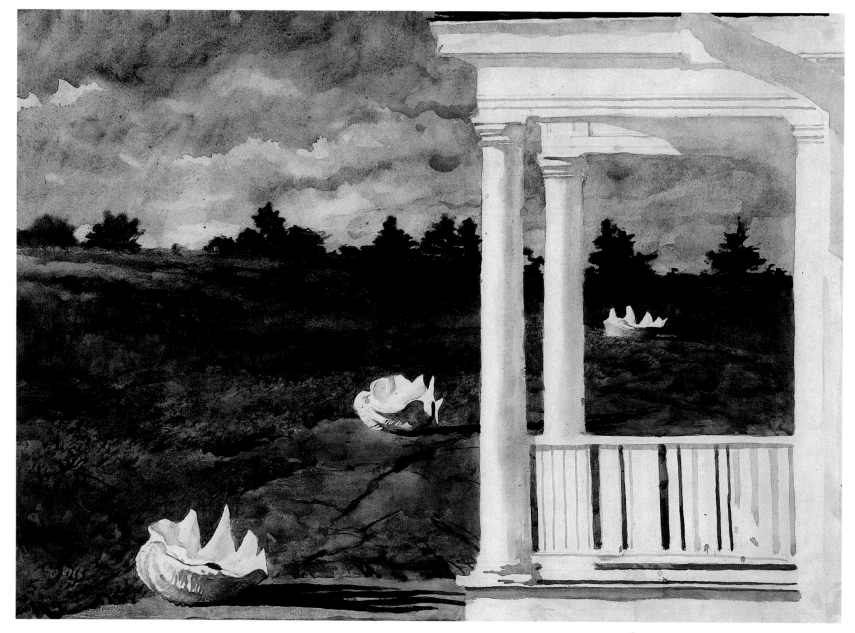

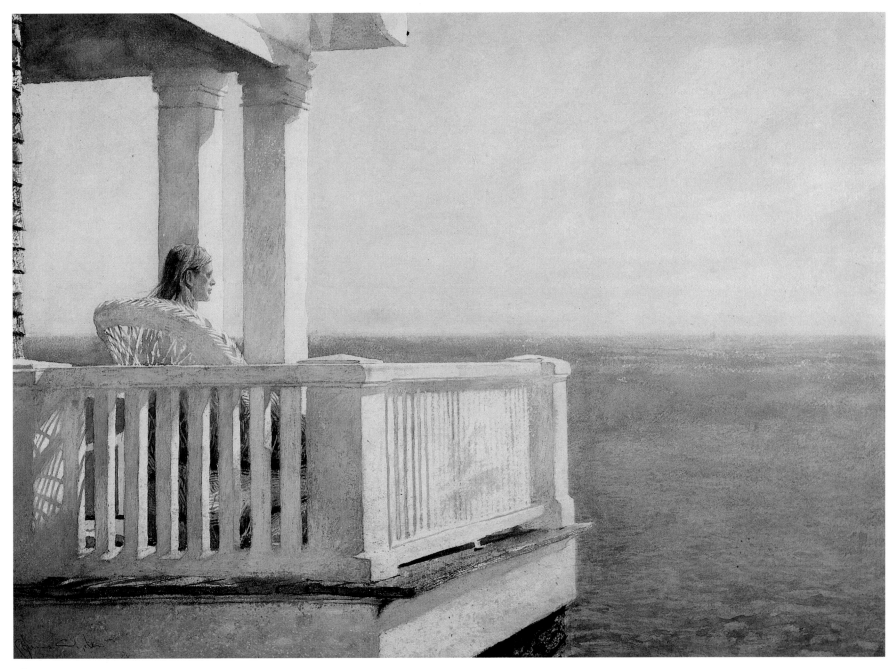

LOOKING SOUTH

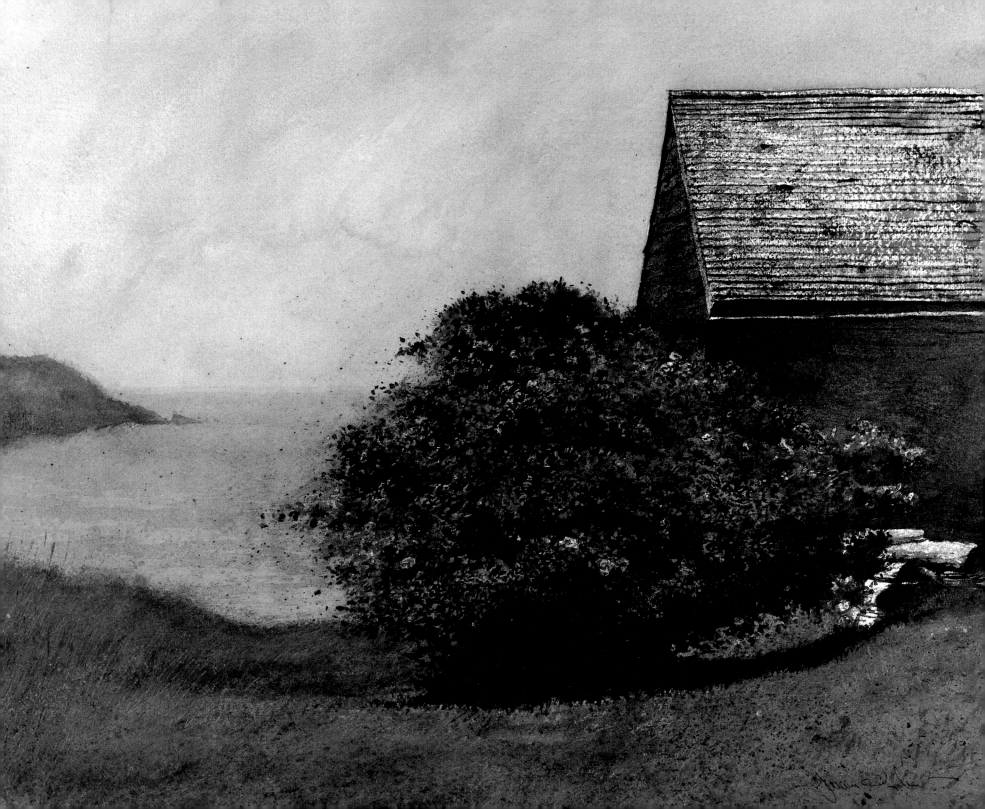

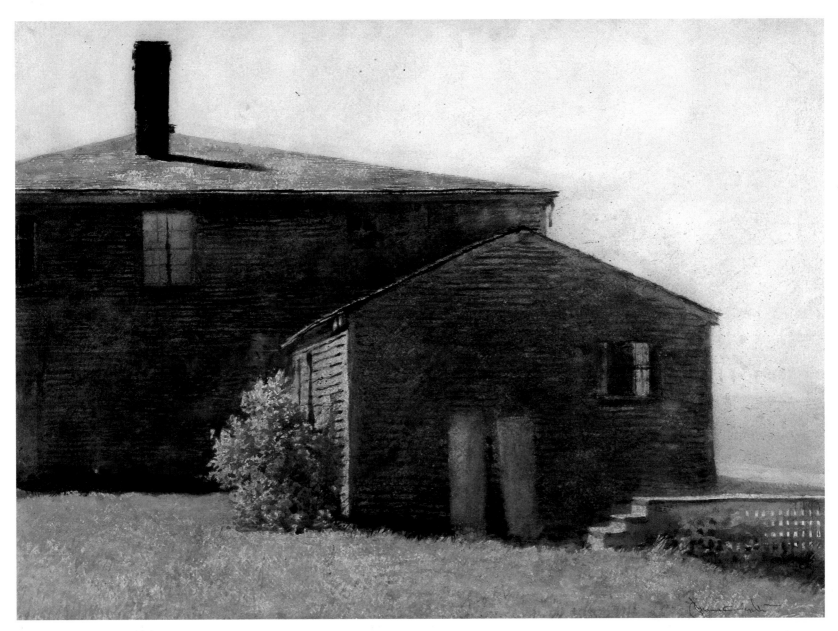

MORNING, MONHEGAN

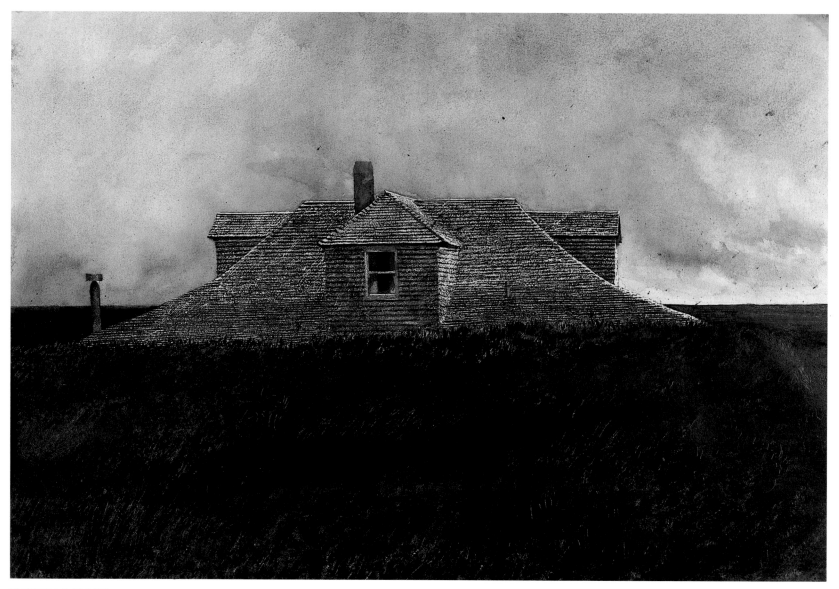

HEKKING HOUSE

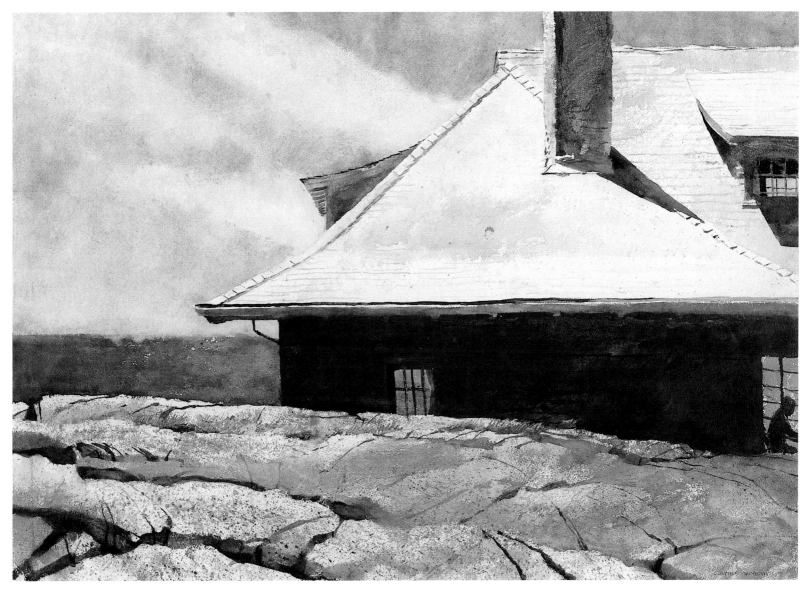

MAN READING, MONHEGAN

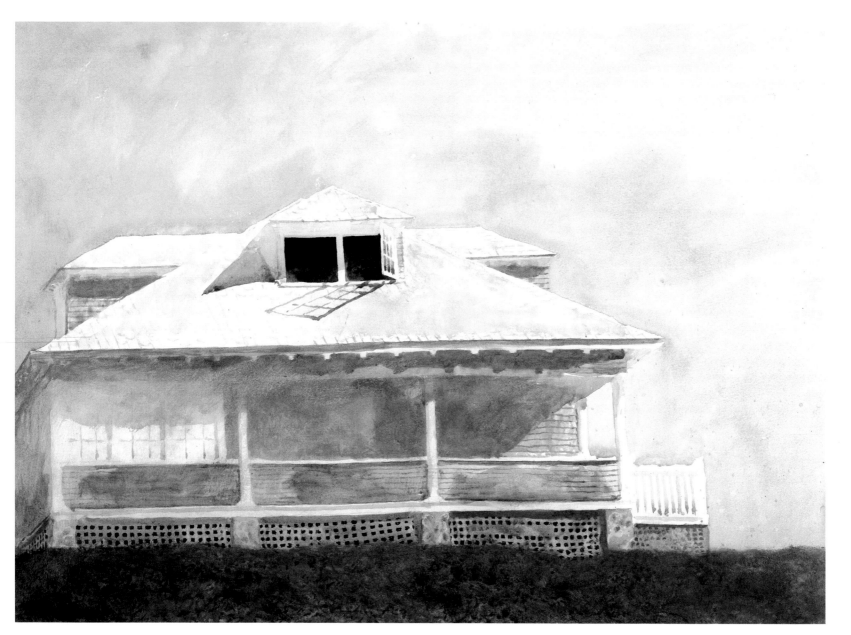

AIRING OUT

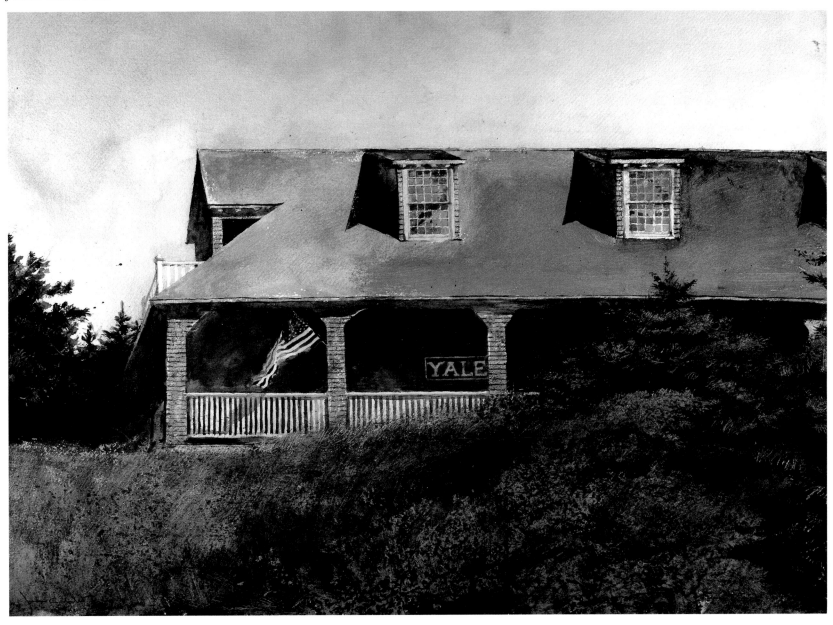

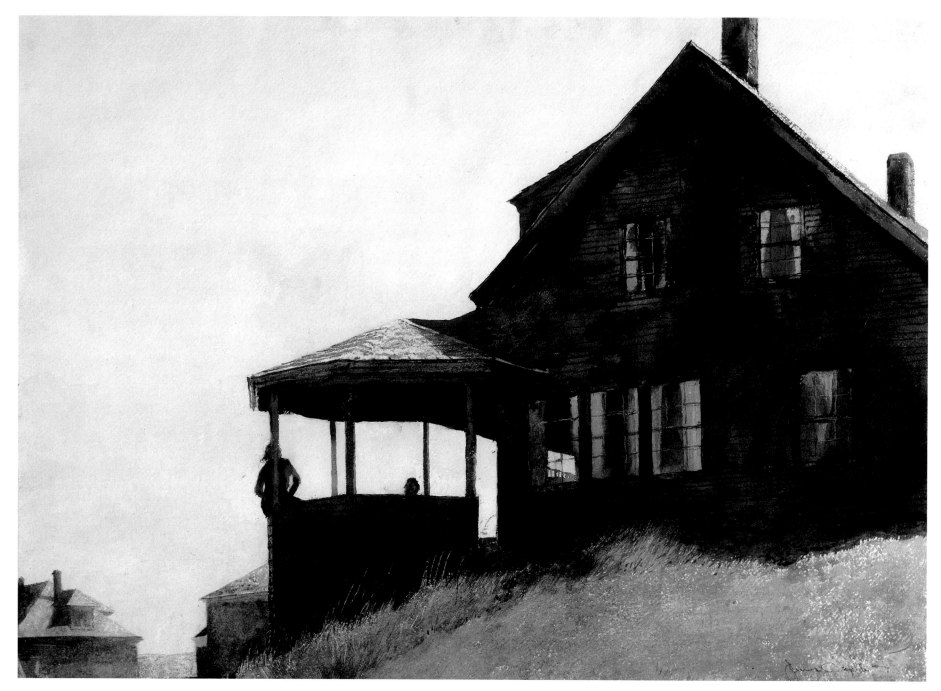

MCGEE'S

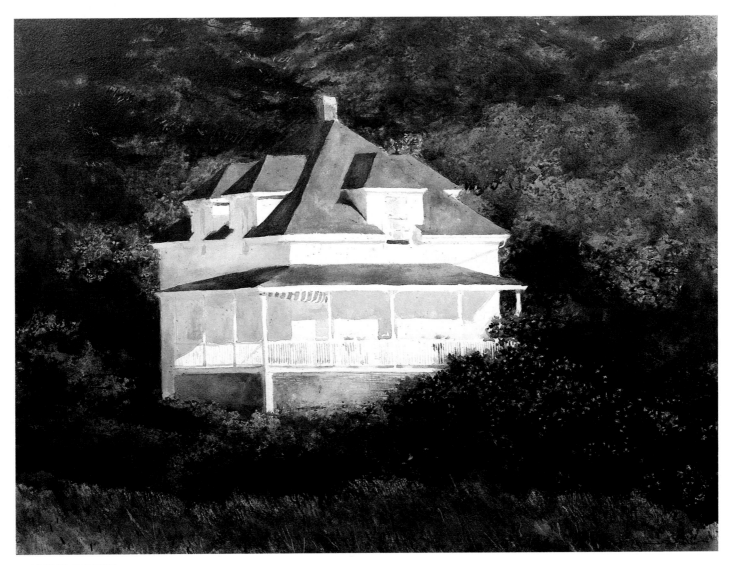

MARTIN HOUSE

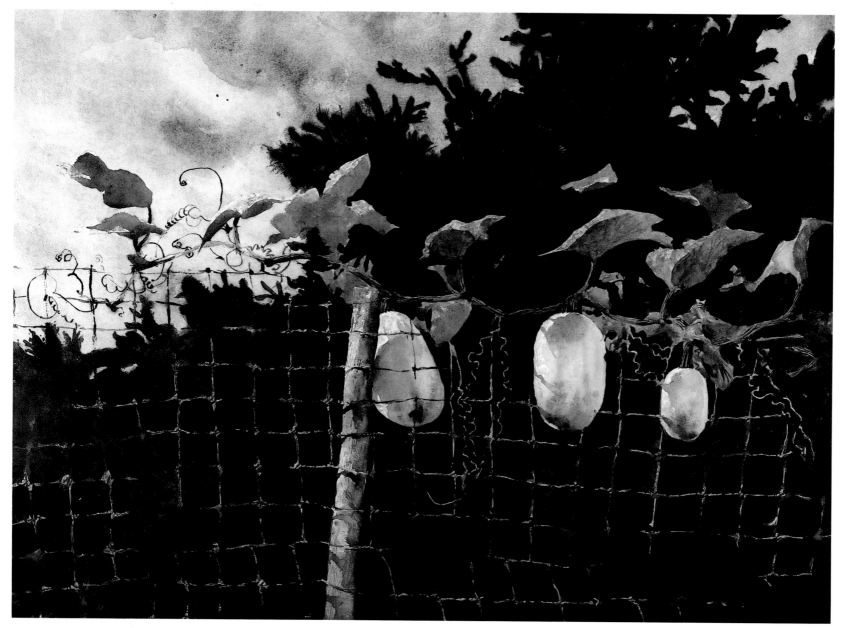

ISLAND SQUASH

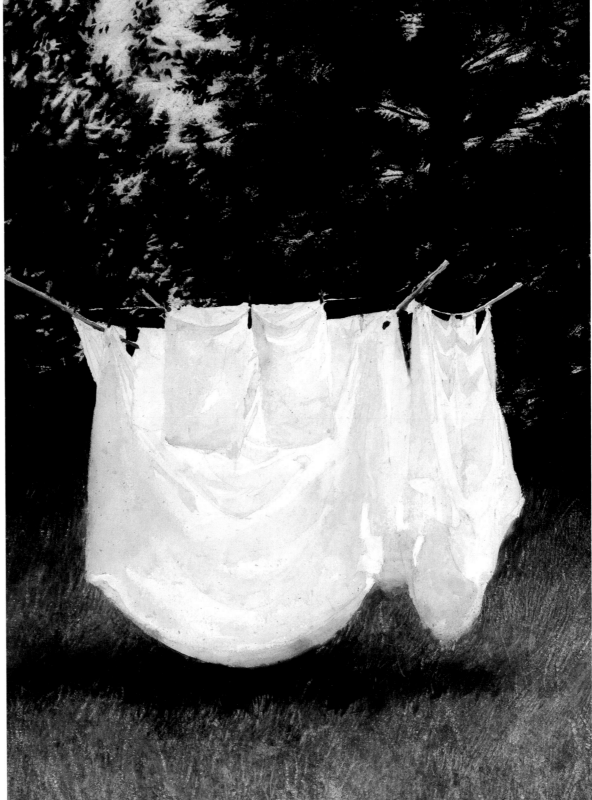

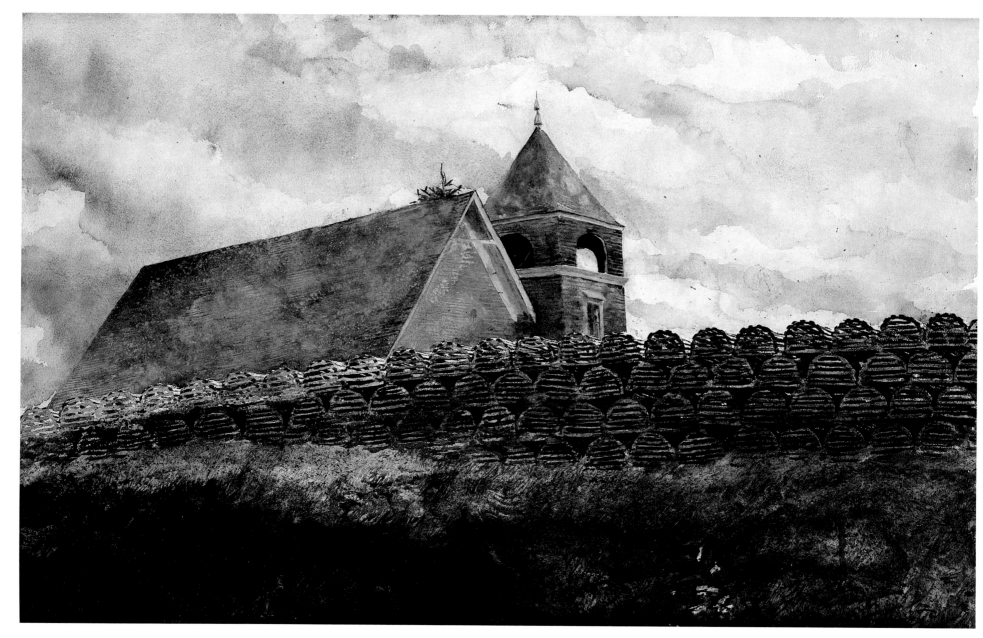

ISLAND CHURCH

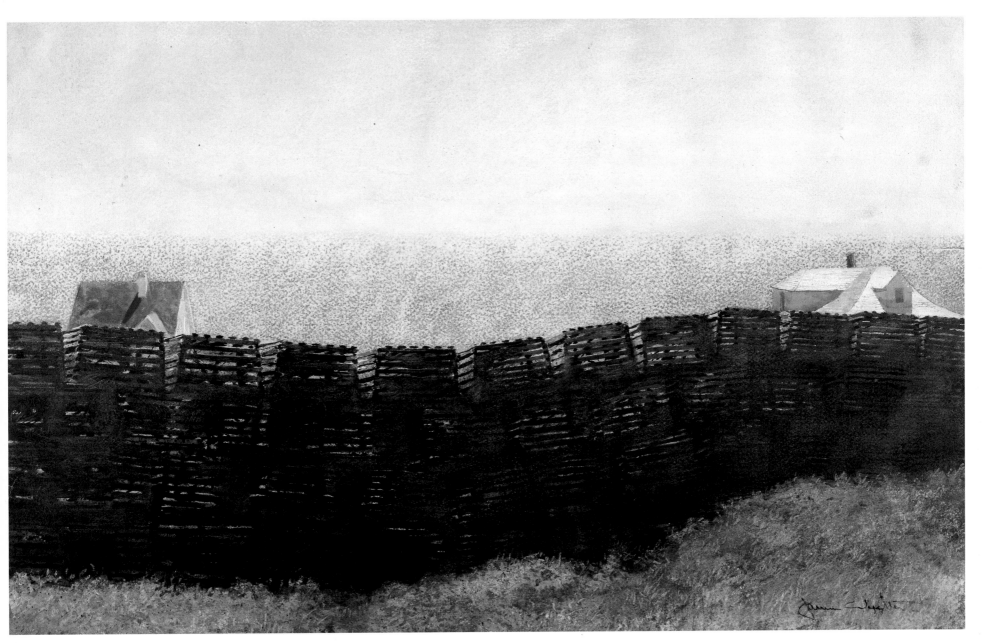

DRYING OUT

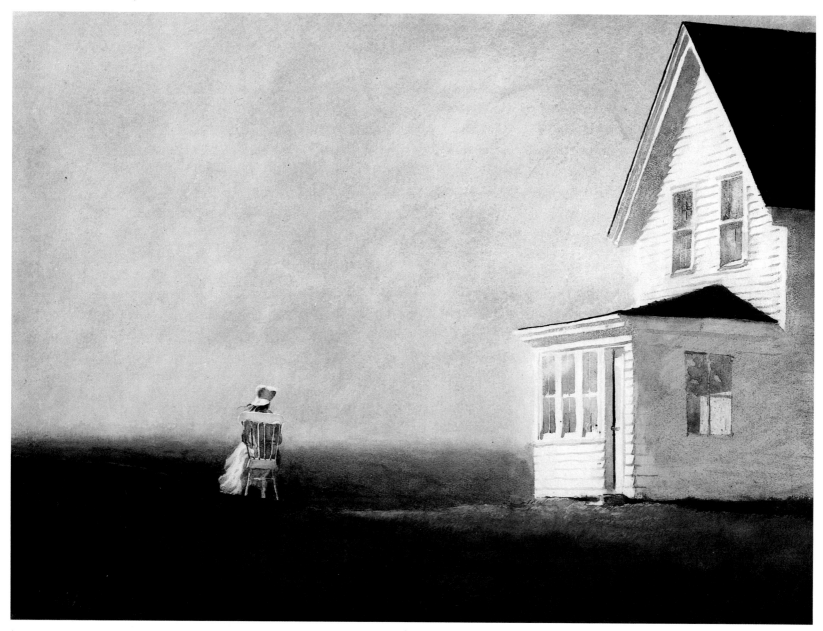

GIRL ON THE ISLAND

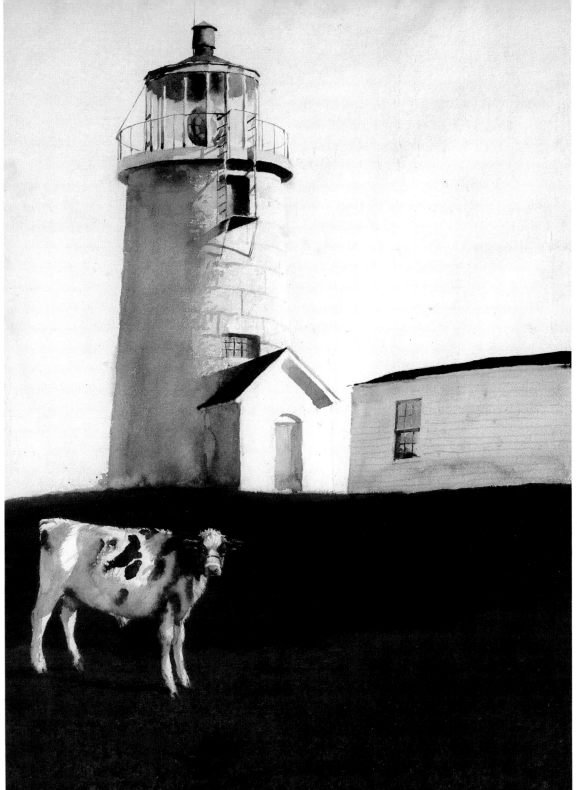

ISLAND STEER

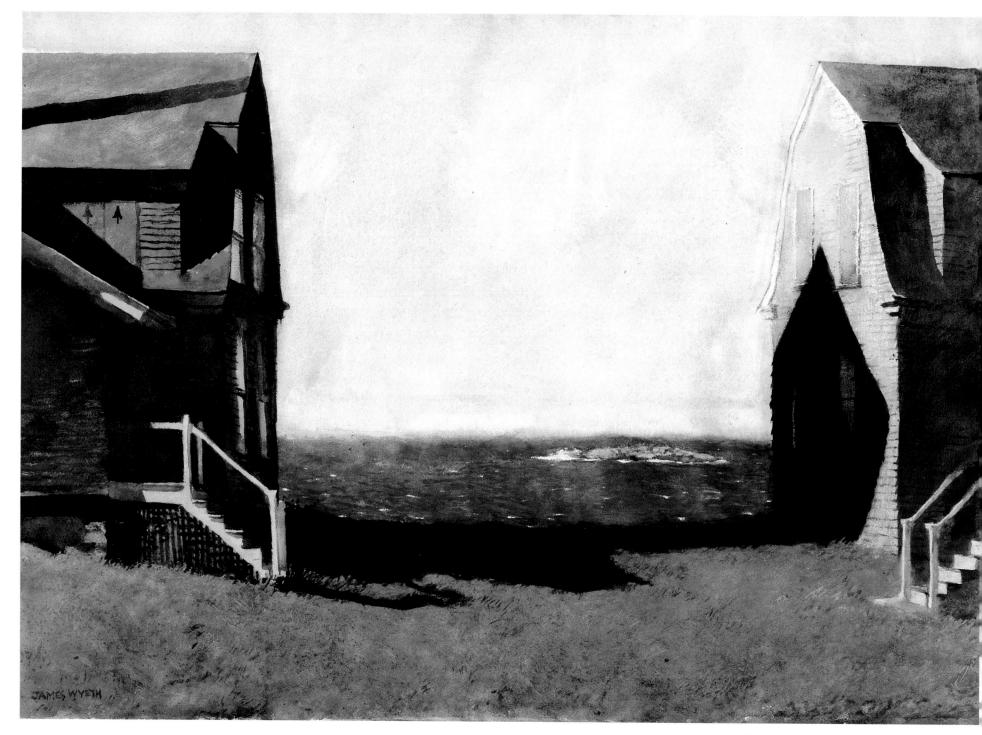

SUMMER HOUSE, WINTER HOUSE

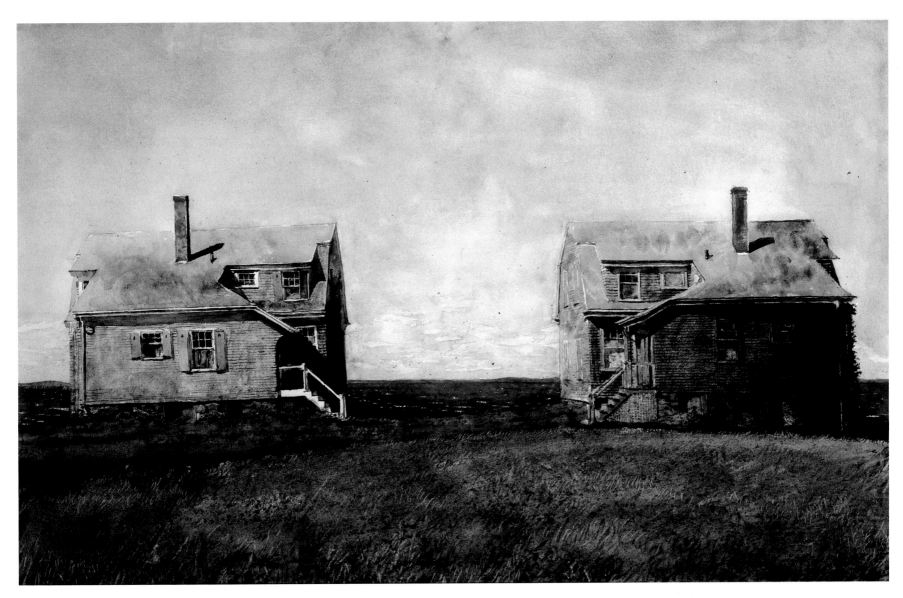

TWIN HOUSES

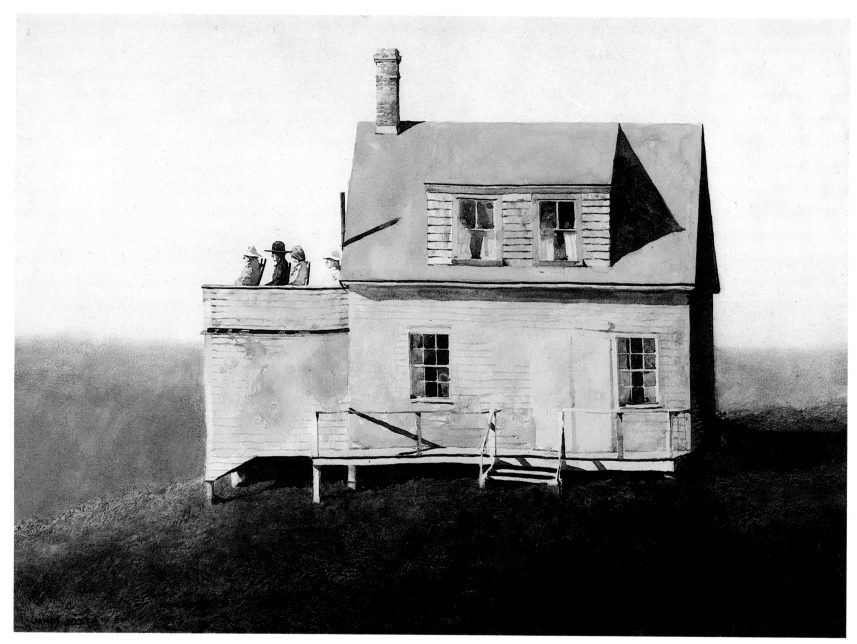

BOAT TIME

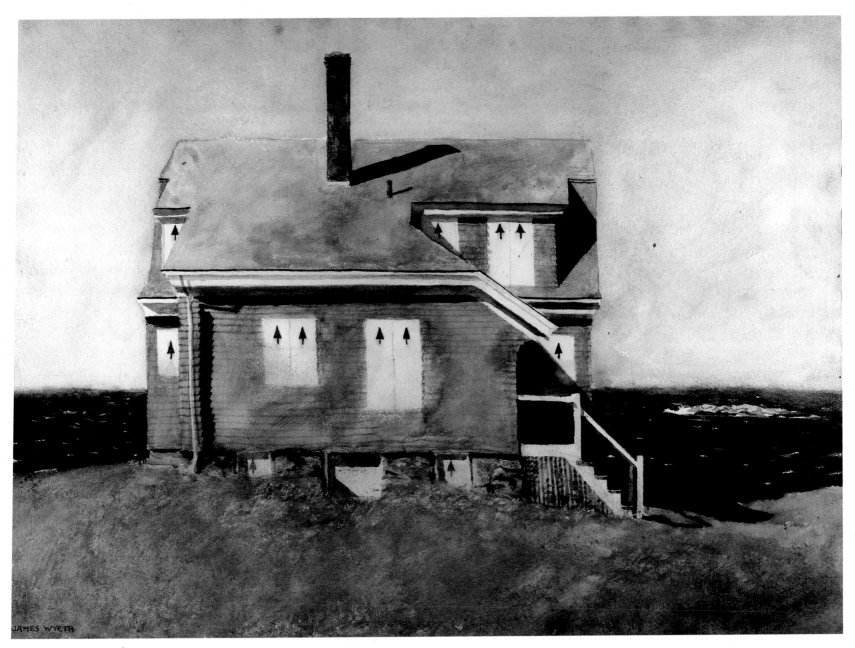

SUMMER PEOPLE'S

THE SEA

EVEN ON A BRILLIANT summer afternoon, one enters the open-ended harbor of Monhegan with a sense of relief. A thin sea mist veils the two-hundred-foot headlands, and the weathered cottages attest to the battles waged with the elements. The North Atlantic has often played hammer to the island's anvil, dashing the hopes and fortunes of untold crews and cargoes upon its forbidding shores. Mindful of this, the fishermen of the island bless their fleet each Spring, with priests in white vestments sprinkling holy water over the trawlers and lobster boats as they set out for another season.

It is this possibility of danger just under the surface that seems to occupy the artist in many of these paintings. Jamie Wyeth has never painted the sea per se; it has always been background rather than subject for him. But however obliquely or inferentially he paints it, its power and challenge are there, front and center — in the tensed arch of a ram's neck, the kindled fire in the stare of the wolf dog, or the latent savagery of the sea gull's eye and beak. Even the sunny stretch of land between shore and wreck speaks of the sea's strength; so, too, do the fragile instruments with which man tries to combat the sea — a life ring or an open launch at the ready.

In spite of all this, the sea's power to destroy is equally matched by its power to attract, and the artist leaves off with a marvelously suggestive giant clamshell finger, beckoning us into the unknown that lies ahead.

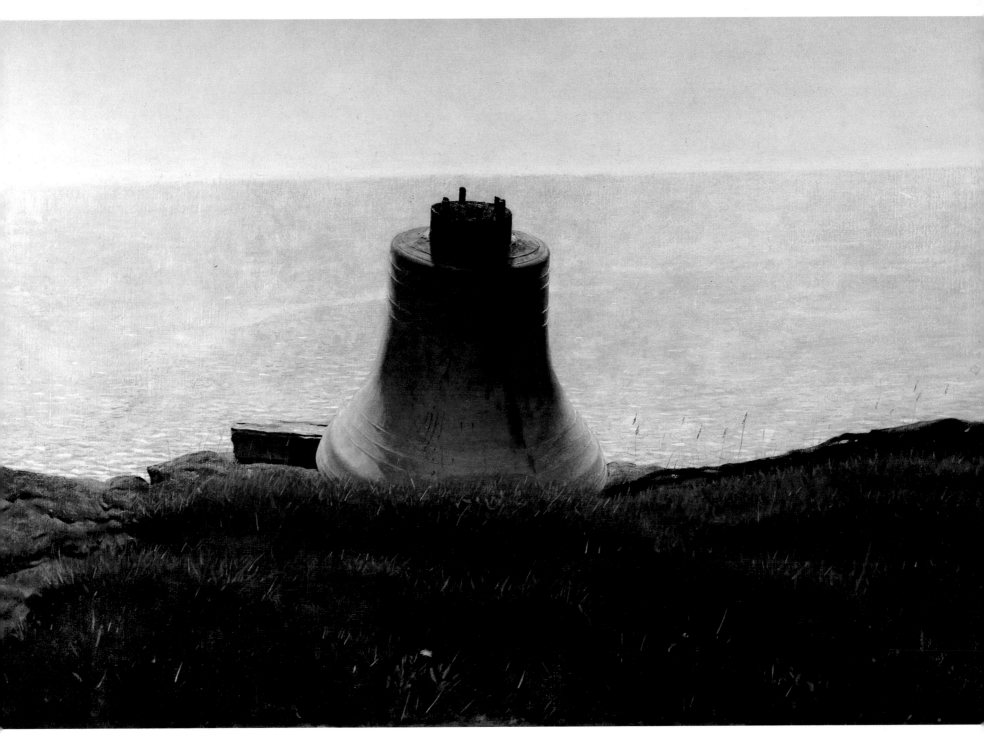

BRONZE AGE

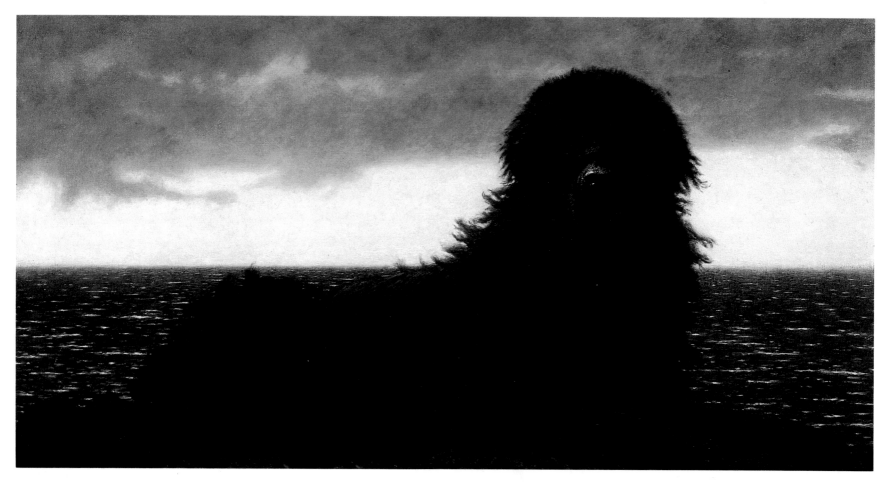

NEWFOUNDLAND

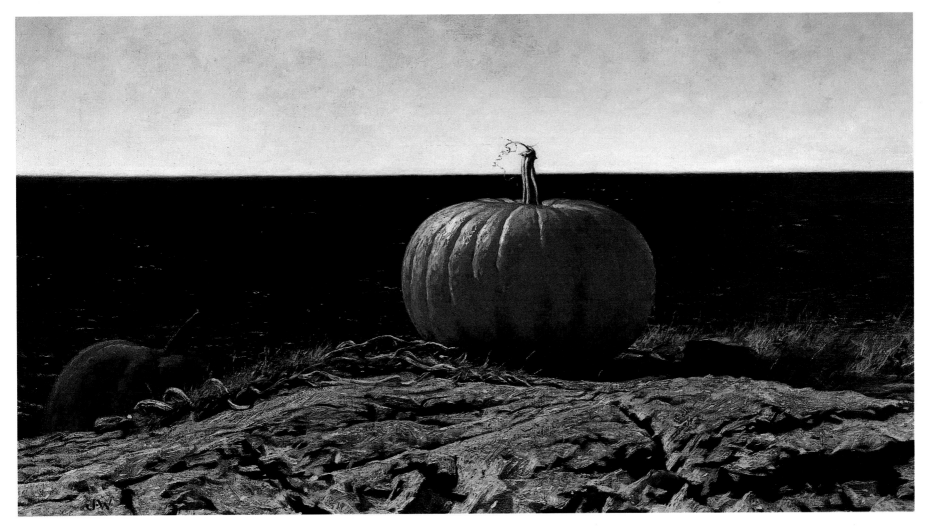

PUMPKINS AT SEA

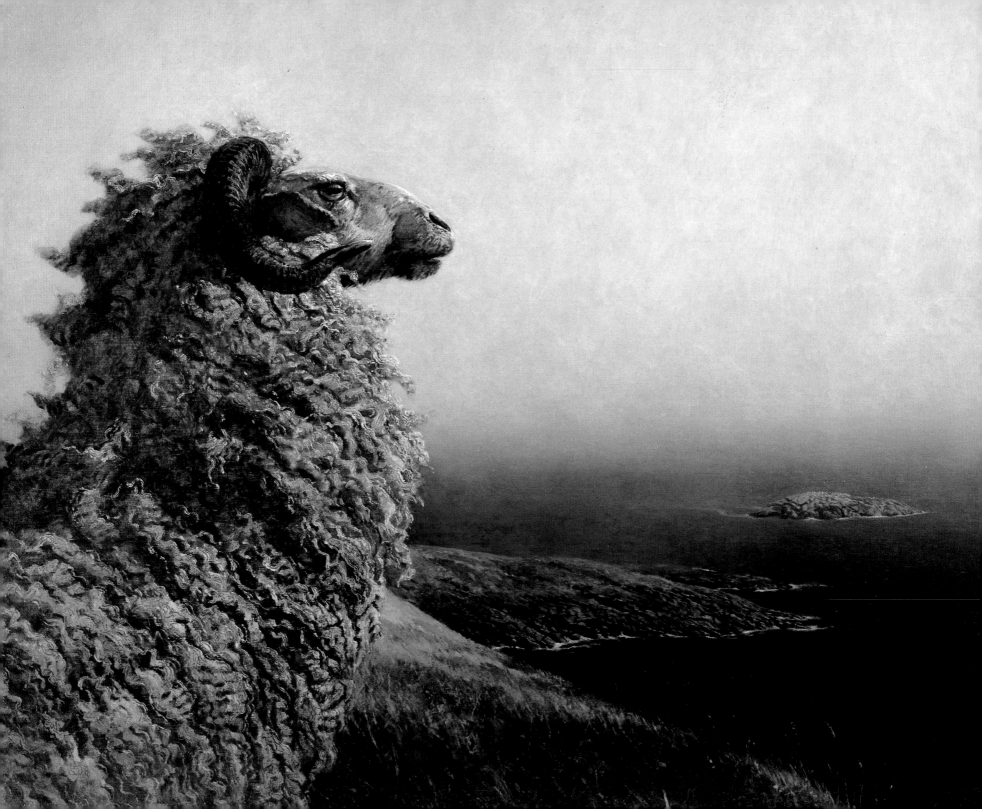

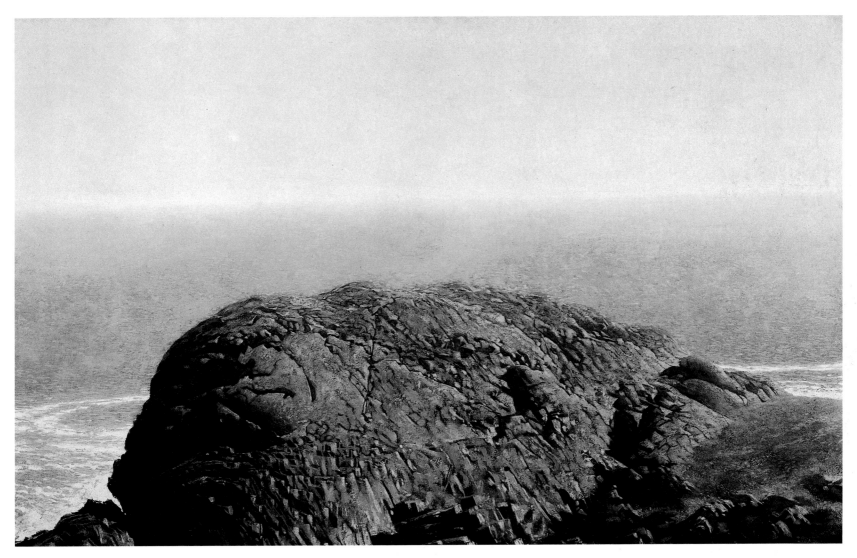

GULL ROCK

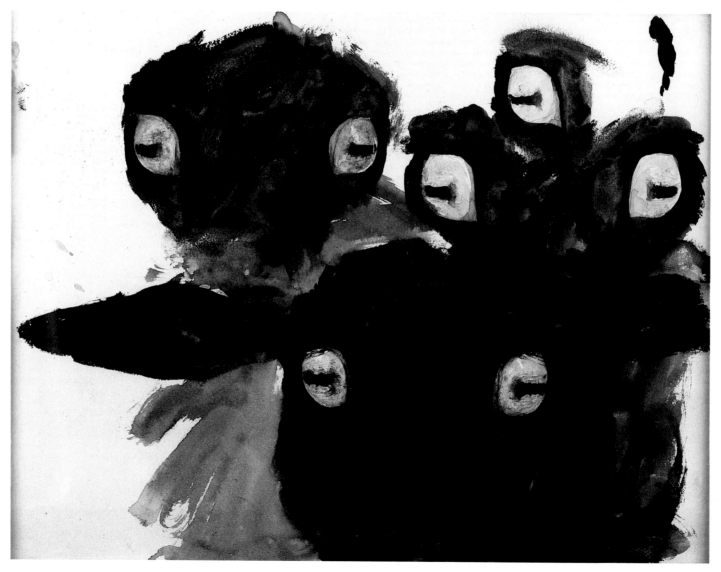

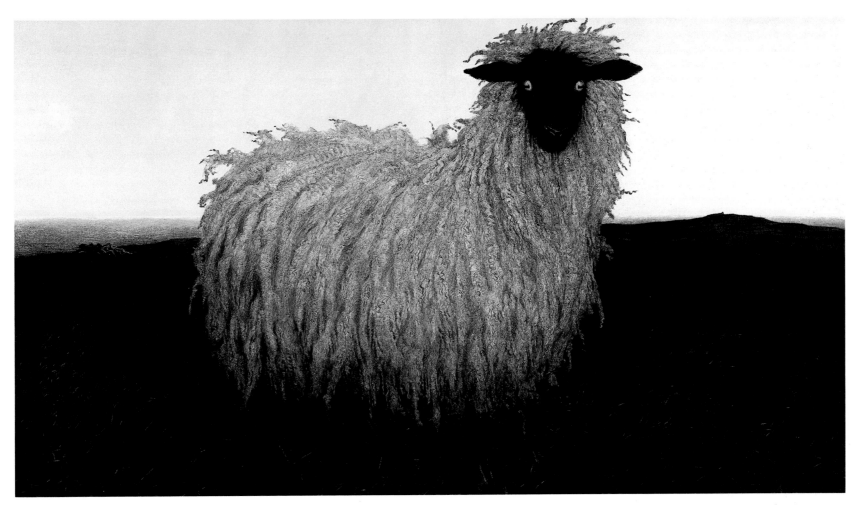

PORTRAIT OF LADY

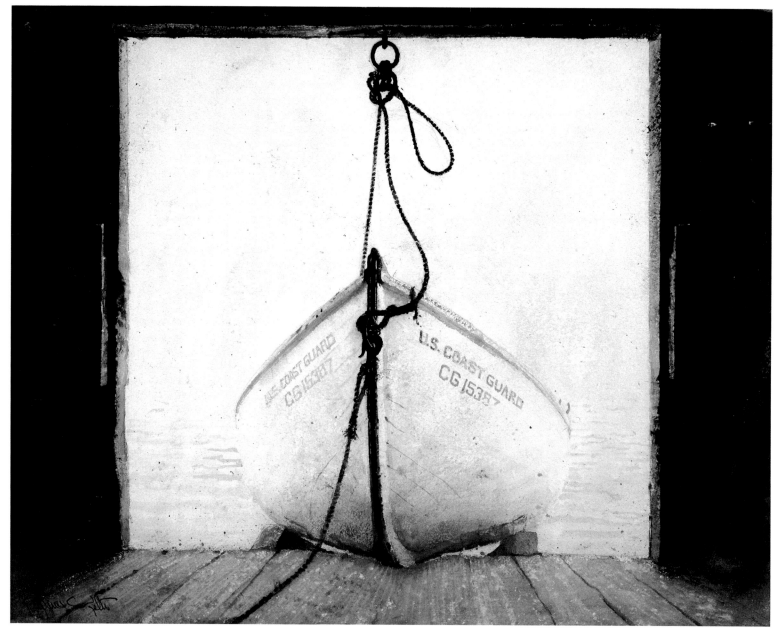

FOG STATION

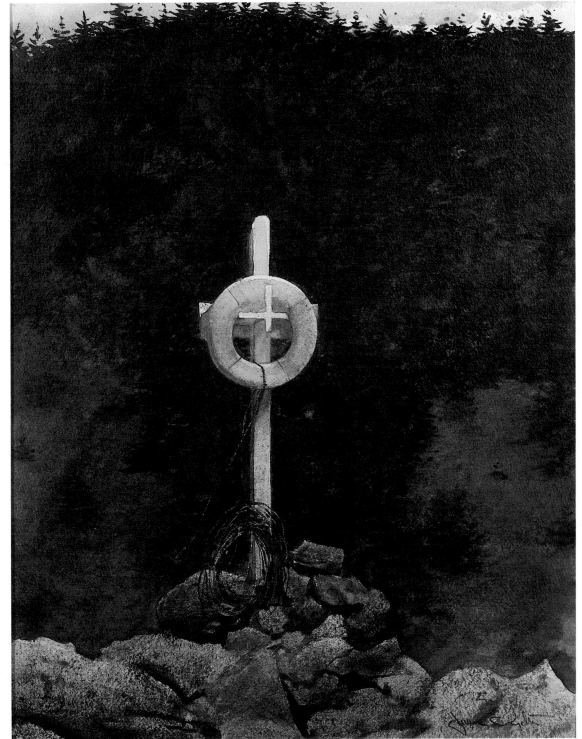

LIFELINE

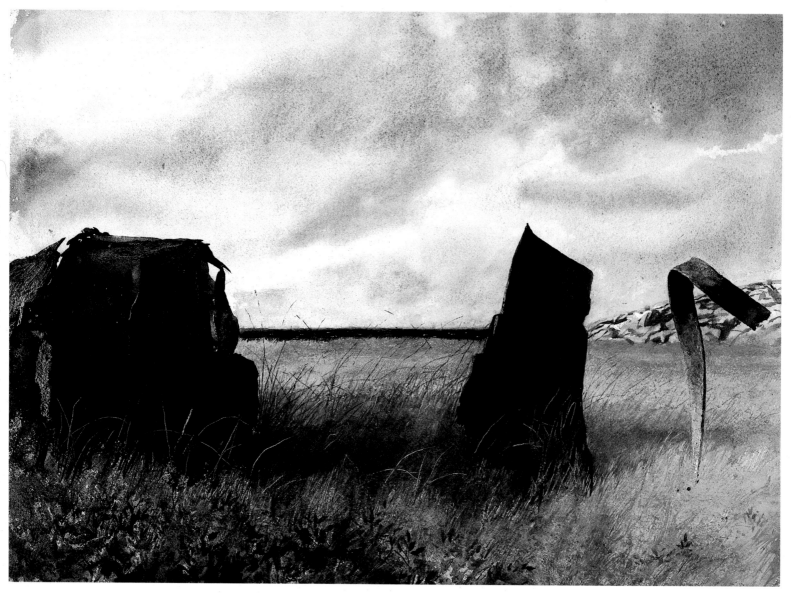

PIECES OF WRECK

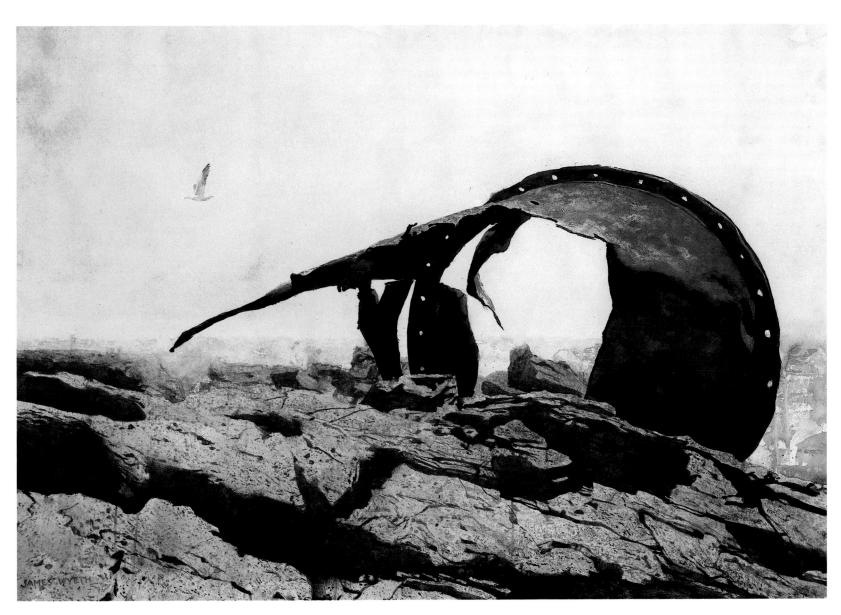

PIECE OF THE WRECK

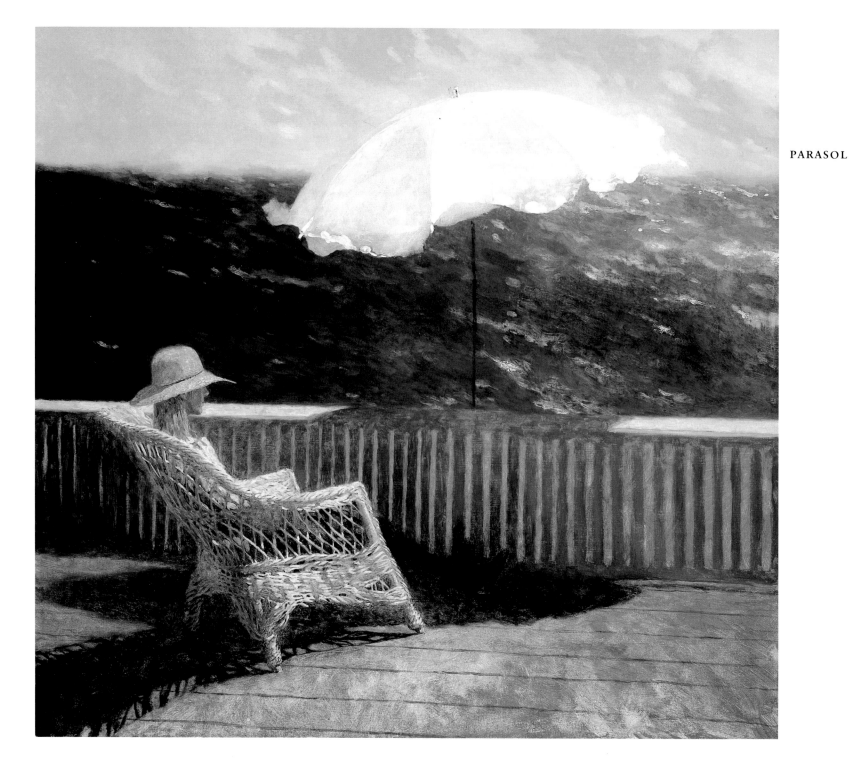

SHARK

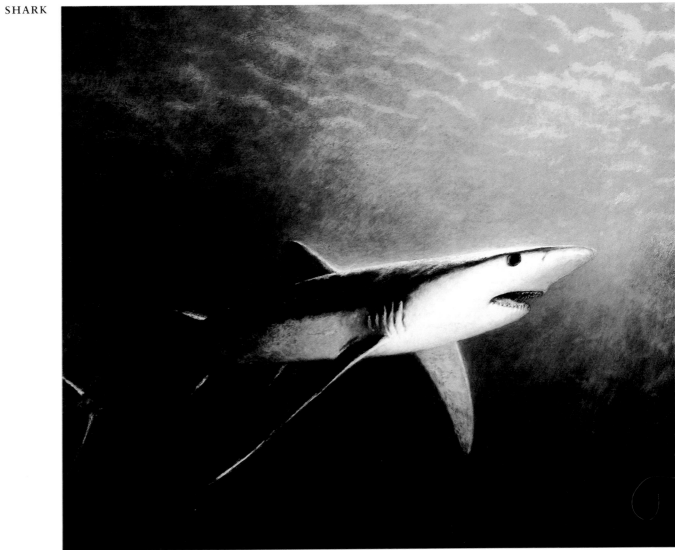

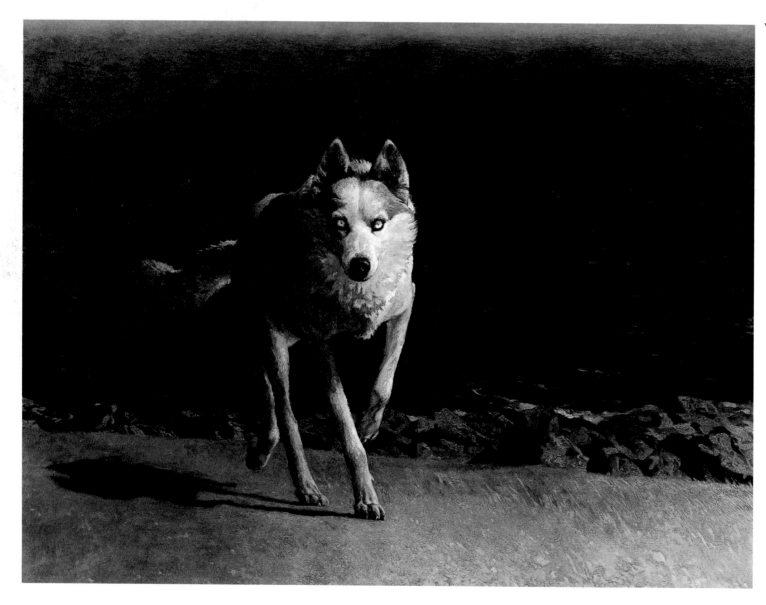

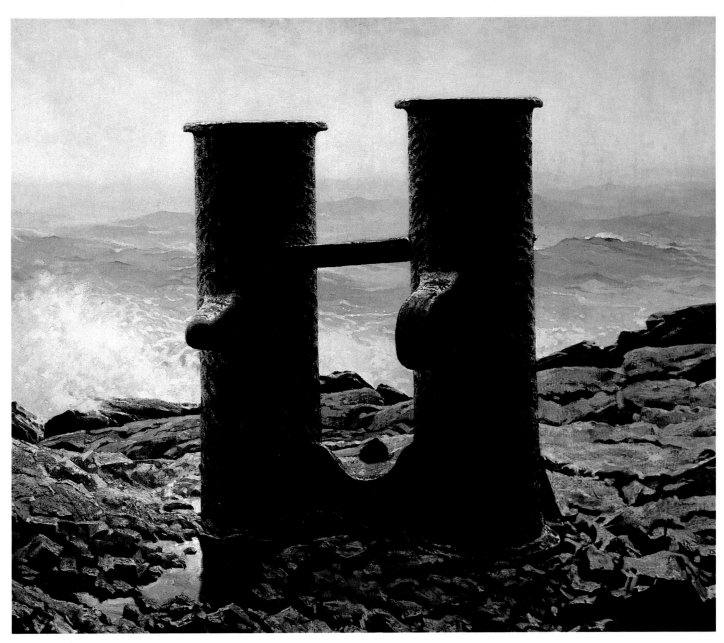

SEA OF STORMS

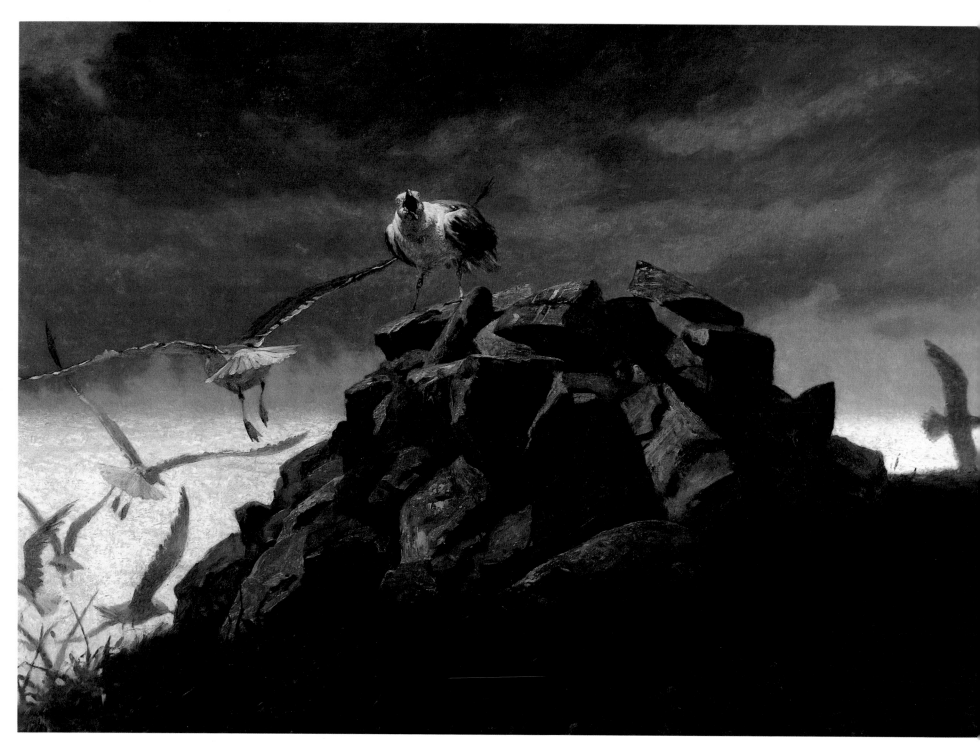

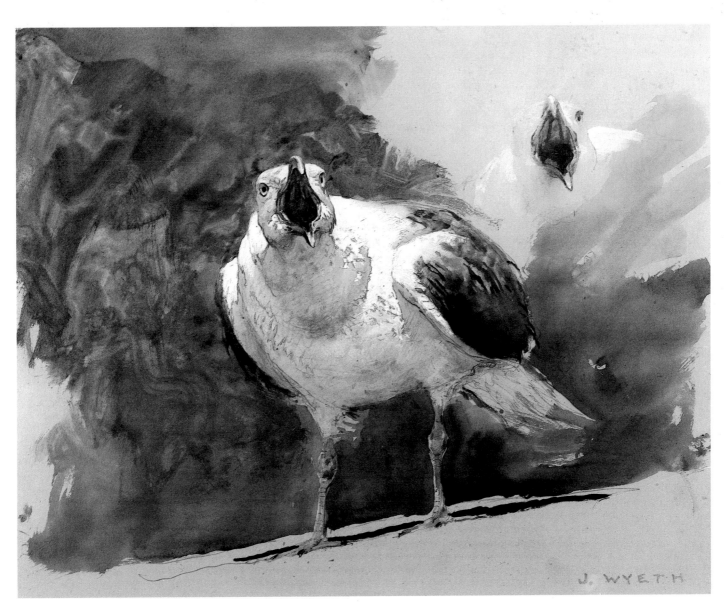

THE ROOKERY—STUDY

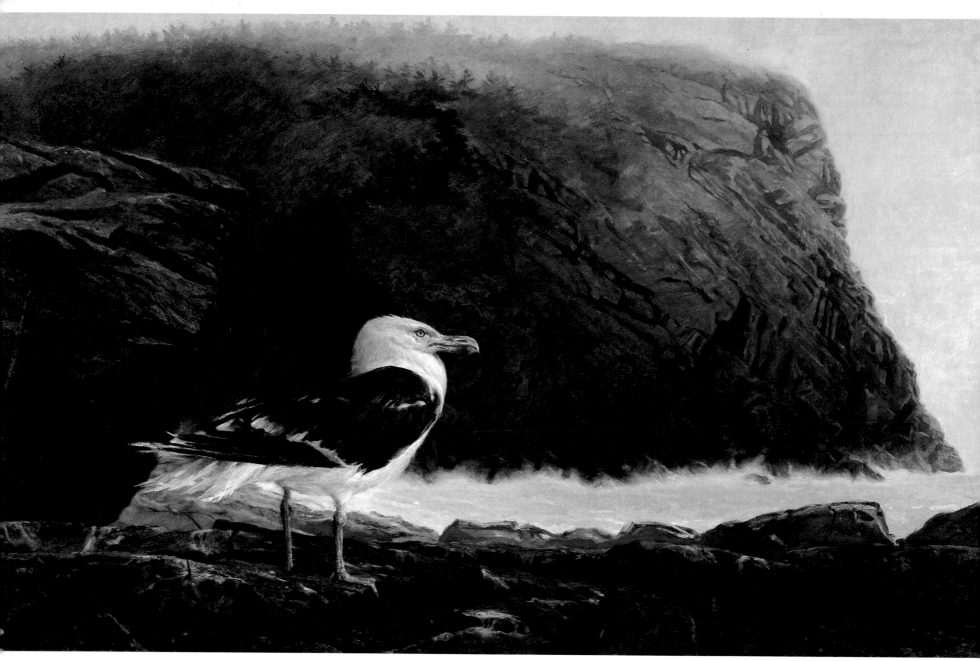

SCAVENGER

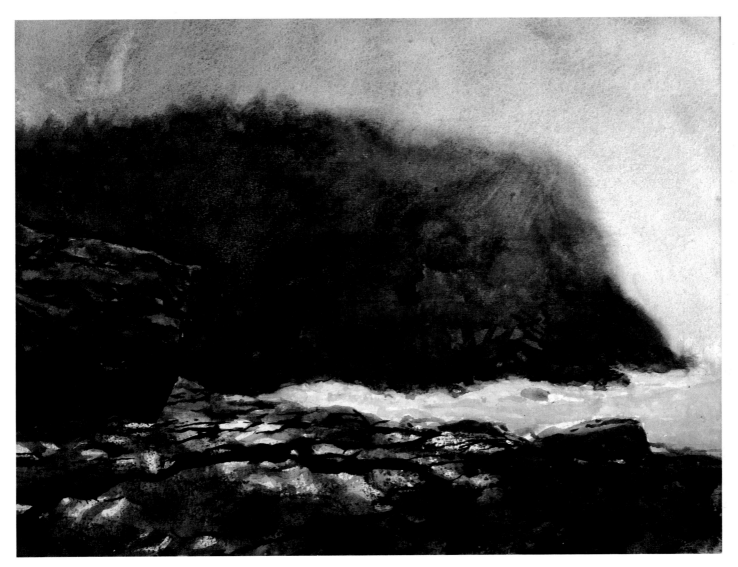

SCAVENGER—STUDY

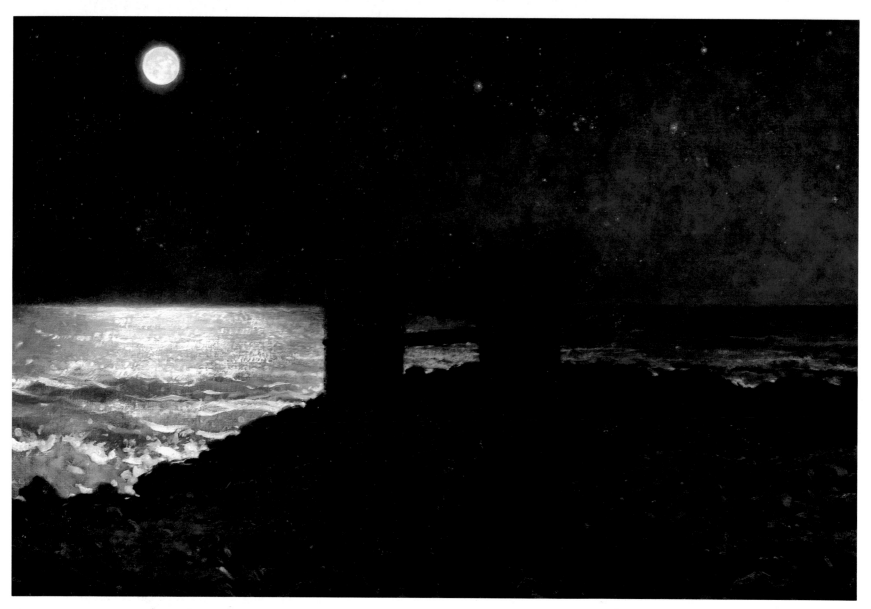

MOON LANDING

GIANT CLAM

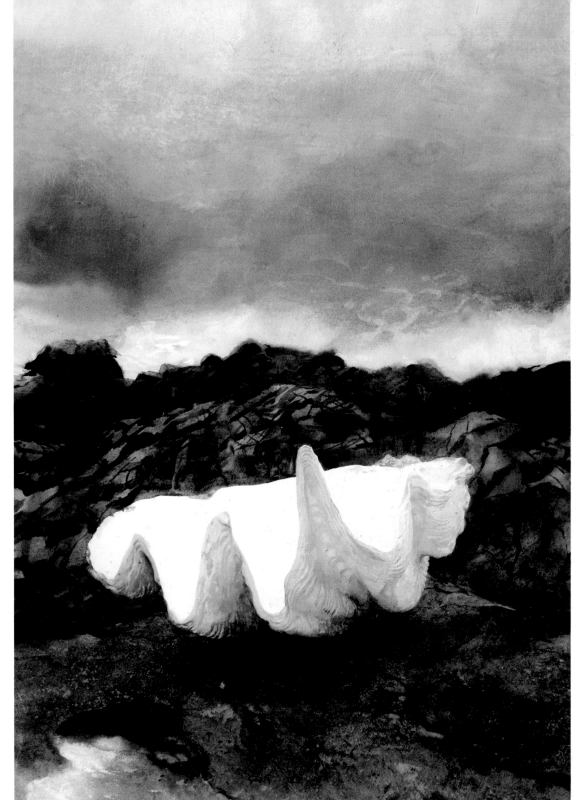

INDEX OF PAINTINGS AND DRAWINGS

SHAPES

33 *Southampton* 1966
Watercolor 22 × 14⅞
Collection of Country Store Gallery,
 Austin, Texas

34 *Corn Crib* 1964
Watercolor 28 × 19
Private collection

35 *Lattice Work* 1967
Oil 16 × 12
Mr. and Mrs. Reed Coleman,
 Madison, Wisconsin

36 *Monhegan Bell* 1978
Watercolor 21½ × 30
Private collection

37 *Landmark* 1971
Watercolor 21⅛ × 29½
Private collection

38 *Hay Loaves* 1975
Watercolor 21 × 29
Private collection

39 *Bale* 1972
Oil 28½ × 35
Private collection

40 *Root Cellar* 1966
Watercolor 28 × 19
Private collection

41 *Due North* 1967
Watercolor 20 × 28
Springfield Art Center

42 *Tin Woodsman* 1968
Watercolor 24 × 19
Private collection

43 *Horse Tub* 1972
Watercolor 21 × 29
Gary W. Kohs Family

44 *Spring Plowing* 1969
Watercolor 20 × 30
Private collection

45 *Big Inch* 1965
Watercolor 18 × 27½
Private collection

46 *Pot* 1969
Oil 18 × 24
Private collection

47 *Pumpkin Pot* 1978
Watercolor 29¾ × 22
Charles B. Seaverns,
 Los Angeles, California

48 *Island Library* 1977
Watercolor 22 × 30
Private collection

49 *Half Cord* 1975
Watercolor 29 × 32
Private collection

50 *Wicker* 1979
Oil 22 × 29
Private collection

51 *Angeload* 1979
Oil 25 × 25
Private collection

PIGS AND THINGS

53 *Pig House* 1970
Watercolor 30½ × 21¾
Robert and Del Noland

54 *Night Pigs* 1979
Oil 30 × 30
Private collection

55 *Portrait of Pig* 1970
Oil 4 × 7
Private collection

56 *Winter Pig* 1975
Watercolor 24 × 36
Private collection

57 *Baby Jane in Summer* 1978
Watercolor 32¾ × 44¼
Anonymous

58 *Pig and the Train* 1977
Oil 24 × 34¼
Private collection

59 *Runaway Pig* 1978
Watercolor 25 × 36
Private collection

60 *House of Pig* 1978
Watercolor 21½ × 30
Frye Art Museum, Seattle, Washington

61 *Switcher* 1977
Watercolor 24 × 36
Private collection

62 *Cooling Off* 1970
Watercolor 22 × 30
Private collection

63 *Pumpkin March* 1974
Watercolor
Anonymous

64 *Whitewash* 1967
Oil 14 × 18
Private collection

65 *Mushroom Picker* 1963
Oil 30 × 49
Private collection

66 *Grackles and Angus* 1974
Oil 28 × 32½
Private collection

67 *Silo and Angus* 1975
Watercolor 21 × 29
Mr. and Mrs. E. L. Pierce Milholland

68 *Angus – Study* 1974
Charcoal 54¼ × 58⅝
Mr. and Mrs. Warren Adelson

69 *Angus* 1974
Oil 52½ × 56½
Private collection

70 *Skewbald* 1978
Oil 40 × 40
Frank E. Fowler Gallery,
 Lookout Mountain, Tennessee

71 *A Very Small Dog* 1980
Oil 50 × 40
Private collection

THE DEEP GORGE

73 *And Then into the Deep Gorge* 1975
Oil 36 × 46
Private collection

74 *Steps* 1972
Watercolor 29½ × 21½
Private collection

75 *Engulfed* 1972
Watercolor 22 × 30
Private collection

76 *New Shoot* 1973
Watercolor 22 × 29
Private collection

77 *New Growth* 1971
Watercolor 29 × 22
Private collection

78 *Fallen* 1975
Watercolor 21 × 30
Private collection

79 *Butts* 1973
Watercolor 22 × 30
Private collection

80 *Giant Dryads* 1979
Watercolor 22 × 30
Collection of Dr. Bruce E. Dahrling II

81 *Tree Fungus* 1977
Watercolor 22 × 30
From the collection of
 Mr. and Mrs. John A. Cron

82 *Torn Spruce* 1975
Watercolor 29 × 21½
Private collection

83 *Croc* 1974
Watercolor 21 × 29½
Private collection

84 *Foot* 1973
Watercolor 21½ × 29½
Mr. and Mrs. Thomas I. H. Powel

85 *River Trunk* 1968
Watercolor 28½ × 18½
Private collection

86 *Brandywine Bluebells* 1975
Oil 16 × 20
Private collection

87 *Where W. Rat Lives* 1978
Watercolor 37 × 25½
Private collection

88 *Brandywine Spiders* 1973
Watercolor 25 × 35
Private collection

89 *Roots* 1971
Watercolor 21 × 30
Private collection

90 *Muddy Waters* 1979
Watercolor 30 × 22
Private collection

91 *Tree Dog* 1976
Watercolor 37 × 25½
Courtesy of the Foster Harmon
 Galleries of American Art,
 Sarasota, Florida

MONHEGAN ISLAND

93 *Kent House* 1972
Oil 30 × 40
Private collection

94 *Obelisk* 1976
Watercolor 22 × 30
Private collection

95 *The Red House* 1972
Watercolor 19 × 29
Private collection

96 *Shell House* 1977
Watercolor 22 × 30
Mrs. Samuel A. Blank

97 *Looking South* 1977
Watercolor 22 × 30
Louise Danelian

98 *Island Roses* 1968
Watercolor 19⅜ × 24⅜
Private collection

99 *Morning, Monhegan* 1972
Watercolor 22 × 30
Mr. and Mrs. Frank E. Fowler

100 *Hekking House* 1968
Watercolor 18½ × 27½
Private collection

101 *Man Reading, Monhegan* 1974
Watercolor 22 × 30
Collection of Mr. and Mrs. Charles G.
 Puchta

102 *Airing Out* 1979
Watercolor 22 × 30
Mr. and Mrs. Buddy Buie

103 *John Cabot III* 1970
Watercolor 21 × 29½
Mr. and Mrs. Nicholas Wyeth

104 *McGee's* 1971
Watercolor 21½ × 29½
Private collection

105 *Martin House* 1973
Watercolor 21¼ × 29½
Private collection

106 *Island Squash* 1979
Watercolor 20¾ × 30¼
Coe Kerr Gallery

107 *Sheets and Cases* 1972
Watercolor 30 × 22
Private collection

108 *Island Church* 1969
Watercolor 19½ × 24½
Private collection

109 *Drying Out* 1972
Watercolor 18¾ × 30
Private collection

110 *Girl on the Island* 1975
Watercolor 22 × 30½
Private collection

111 *Island Steer* 1976
Watercolor 29 × 21
Private collection

112 *Summer House, Winter House* 1975
Watercolor 22 × 30
From the collection of Mr. and Mrs.
 Phil Walden

113 *Twin Houses* 1969
Watercolor 19 × 30
Collection of United Missouri Banc-
 shares, Kansas City, Missouri

114 *Boat Time* 1976
Watercolor 21 × 29
Private collection

115 *Summer People's* 1974
Watercolor 29 × 32
Mr. and Mrs. E. Garrett Bewkes, Jr.

THE SEA

117 *Bronze Age* 1966
Oil 24 × 36
William A. Farnsworth Library and
 Art Museum, Rockland, Maine

118 *Newfoundland* 1971
Oil 30 × 58
Mr. and Mrs. Jack E. Craig,
 Fort Wayne, Indiana

119 *Pumpkins at Sea* 1971
Oil 22 × 40
Private collection

120 *The Islander* 1975
Oil 34 × 44
Private collection

121 *Gull Rock* 1970
Oil 25 × 40
Private collection

122 *Sheep Eyes* 1968
Watercolor 9 × 12
Private collection

123 *Portrait of Lady* 1968
Oil 35¾ × 63½
Private collection

124 *Fog Station* 1967
Watercolor 19½ × 24½
Private collection

125 *Lifeline* 1968
Watercolor 24 × 19
Private collection

126 *Pieces of Wreck* 1973
Watercolor 21½ × 29½
Arthur A. Carota

127 *Piece of the Wreck* 1977
Watercolor 25 × 36
From the collection of
 Mr. and Mrs. Andrew J. Pan

128 *Parasol* 1979
Oil 26 × 28
Private collection

129 *Shark* 1974
Oil 52 × 60
Private collection

130 *Wolf Dog* 1976
Oil 30 × 40
Mr. and Mrs. Frank E. Fowler

131 *Sea of Storms* 1970
Oil 38 × 45
Depositors Corporation,
 Augusta, Maine

132 *The Rookery* 1977
Oil 31 × 43
PepsiCo, Inc., World Headquarters,
 Purchase, New York

133 *The Rookery – Study* 1977
Mixed media 15½ × 19½
Private collection

134 *Scavenger* 1974
Oil 34 × 54
Private collection

135 *Scavenger – Study* 1974
Watercolor 12 × 16
Private collection

136 *Moon Landing* 1969
Oil 29 × 43
Private collection

137 *Giant Clam* · 1977
Watercolor 34 × 23
Dolly Bruni

This book was designed by Klaus Gemming,
New Haven, Connecticut.

The text was set in Linofilm Sabon
by Finn Typographic Service, Stamford, Connecticut.

The printing plates were prepared and the book was printed
by the Acme Printing Co., Inc., Medford, Massachusetts,
using four color process sheet-fed lithography.

The text paper is Lustro Offset Enamel Dull,
manufactured by the S. D. Warren Company,
a division of the Scott Paper Company.
The cover fabric is Fairfield Natural,
produced by the Joanna Western Mills Company.

The book was bound by A. Horowitz and Sons, Bookbinders,
Fairfield, New Jersey.

Tout bien ou rien